IMAGES
of America

FRANKENMUTH

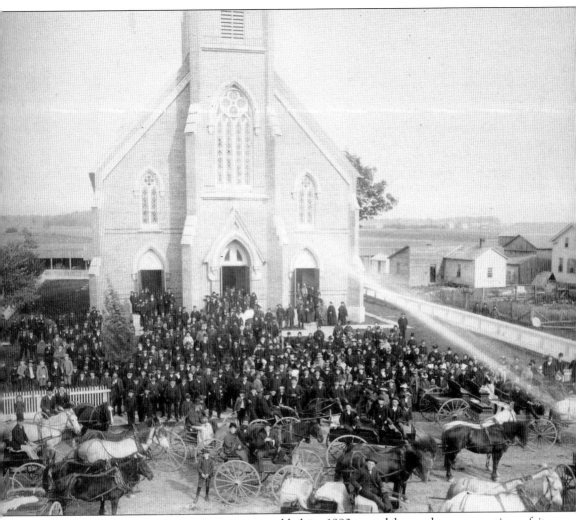

When the St. Lorenz congregation assembled in 1880 to celebrate the consecration of its beautiful Gothic church, it was an expression of gratitude. Its first pastor, August Craemer, traveled back to Frankenmuth from Springfield, Illinois, where he was then a professor at the Lutheran seminary, to deliver the dedication sermon, reminding congregants of the humble beginnings in the log church. But the new church was also a monument to their trust in the future. With a seating capacity of 1,000, they must have visualized that this house of God would continue to serve many future generations, as it has.

On the cover: Frankenmuth has long been noted for the quality and quantity of its celebrations. In the early years, baptisms, confirmations, weddings, and even funerals were community-wide events. An essential component of the Lutheran heritage was music. In this picture from about 1900, a horse-drawn wagon carries the fully uniformed Frankenmuth Cornet Band southward on Main Street, leading a wedding parade, probably en route from the church to one of the downtown hotels. (Courtesy of Frankenmuth Historical Association.)

IMAGES
of America

FRANKENMUTH

Frankenmuth Historical Association

ARCADIA
PUBLISHING

Published by Arcadia Publishing
Charleston SC, Chicago IL, Portsmouth NH, San Francisco CA

Printed in the United States of America

Library of Congress Catalog Card Number: 2008926311

For all general information contact Arcadia Publishing at:
Telephone 843-853-2070
Fax 843-853-0044
E-mail sales@arcadiapublishing.com
For customer service and orders:
Toll-Free 1-888-313-2665

Visit us on the Internet at www.arcadiapublishing.com

CONTENTS

ACKNOWLEDGMENTS

The primary impetus for this book has come from Jonathan Webb, director of the Frankenmuth Historical Association. To assist in the selection of the photographs it contains, he enlisted a committee of four, all members of the association and all direct descendants of the early settlers: Franklin Kern, Alan Knoll, David Maves, and Wallace Weiss. The writing of the captions and other textual material was predominantly by Maves, author of the sesquicentennial publication *How Firm a Foundation* and who has also written for *Michigan History* magazine, the *Frankenmuth News*, and the association newsletter.

Except as noted, all images are from the archives of the Frankenmuth Historical Museum. We gratefully acknowledge the assistance of collection manager Mary Nuechterlein and volunteer Verna VanDevelde for their valiant efforts in researching and scanning the individual images. The committee is also indebted to Marie Bierlein, who provided an additional independent review of the page proofs.

The most obvious dedication for our efforts in this book would be to those who lived the history. We might start with Pastor Wilhelm Loehe, whose mission-minded compassion first visualized the frontier colony. Or we might recognize the courage and faith of those first settlers to whom our committee members can directly trace their roots. There are also the many intervening generations of the farm and business families whose hard work and perseverance built the Frankenmuth of today.

But shortly after we began this project, we were saddened by the death of Wallace J. Bronner, originator of Bronner's CHRISTmas Wonderland. He was a personal friend of all of us as well as a great benefactor to our community. But most of all, he was a personification of the Christian ideals that have been the foundation and guidance behind the story we are telling. In honoring him, we also honor the heritage that he loved and enriched.

INTRODUCTION

Good history is never totally objective, nor should it be. Any story worth hearing bears the imprint of the storyteller and is not just some dry recitation of dates and incidents. Since this story is being told by pictures, clearly the selection process has influenced the story.

Anyone with some independent knowledge of Frankenmuth history might question why certain pictures are in the book and others are not. With the vast collections of the Frankenmuth Historical Museum as well as personal archives available, there were literally thousands. The ones that were chosen were thought to best tell the story. No pretense to being uniquely suited was made, but the authors share an abiding admiration of, and affection for, local history and have lived through a good portion of it.

Many of the pictures contain people, who will be briefly identified where possible. But it is the what and not the who that deserves the emphasis. The advent of photography dictated the starting point. Concluding the period at the World War II era was primarily a matter of space limitation. The tourism industry, which burgeoned after that time, is deserving of its own book, and several are available.

On the last day of July in the year 1845 at a land office in Flint, a purchase was concluded. European coins with a value of $1,700 were exchanged for 680 acres of undeveloped United States government territory. It marked a time of beginnings and a time of endings.

Less than a decade earlier, that property belonged to the Chippewa Nation. The river, known to the Chippewas as the River of the Hurons, had recently been renamed the Cass River in honor of the statesman who negotiated most of their lands away from them. The soon-to-be village of Frankenmuth overspread what earlier was the village of Chief Otusson.

In many ways, the transition was merely one more instance of the natural progression from a hunting-and-gathering culture to one based on farming. In terms of productivity, it was clearly a more efficient use of available resources. Many more mouths could be fed from any given parcel of land.

Yet the primary rationale behind the Frankenmuth settlement was altruistic, not economic. It was a community envisioned by a German Lutheran pastor named Wilhelm Loehe. His intent was to share the Christian Gospel with the native Chippewas while simultaneously providing a spiritual refuge for future emigrants from a troubled homeland in the Franconian region of the kingdom of Bavaria.

That religious impetus, as manifested in the St. Lorenz congregation, cannot be overemphasized. The first line of the first set of regulations, adopted and signed by every adult male member of the fledgling community, is written considerably larger than the rest. Translated into English, it reads, "God is a God of order."

That belief in divinely ordained order was reflected in roads of a specified width, fences of a designated height, straight furrows, and clean ditches. For almost any activity, there was an acknowledged way in which it should be done and the expectation of compliance. Any disputes were submitted to the pastor for resolution.

Nevertheless, all was not somber. The Franconians were an earthy people, heartily enjoying fellowship and even festivity once their daily labors were completed. The venerated Dr. Martin Luther was reputed to also appreciate good secular music and an occasional stein of beer, all in moderation, of course.

Initially the relative isolation of their forest home forged staunch bonds of interdependence as a matter of survival. Later arrivals to the community were family and friends from the same villages in the old country, and so all shared the unifying Franconian German Lutheran heritage.

Most were well satisfied with the culture and traditions that stretched back over many generations. Melded with the bountiful natural resources that they nurtured in their new location, the only impetus for commercial developments were the enterprises necessary to supplement their agrarian self-sufficiency.

For almost three weeks after the land purchase, the men worked diligently in the summer heat, clearing a space on the ridge overlooking the river. From the resulting logs, they constructed the crude huts to provide shelter. On August 18, the women came from Saginaw, where they were staying, and the community was established.

Significantly, there were two of those first structures. One served as a common dwelling, while the other was reserved for religious services and as a parsonage. Until the completion of a more sturdy structure over a year later, that 10-foot-by-30-foot hut was their church. Each day began and ended with communal devotions.

Within a generation, the regional trees became known as Cass River cork pine, the gold standard of the timber industry. Within another generation, they were gone, along with the interspersed hardwoods of the virgin forest. But at the outset, they formed a troublesome barrier between the settlers and their livelihood as farmers.

With some of the logs exceeding six feet in diameter, the only option was to burn them where they were felled. The remaining stumps were too firmly anchored to be extracted, and the heavy, rich soil was so densely interlaced with centuries of roots that the power of oxen was required to cut those first furrows.

Both the trees they found and the grain they grew required additional processing to be useful. The logs needed to be converted to lumber and the grain to flour by the community's first commercial enterprises, the sawmill and gristmill. The only available source of mill power in that wilderness was the Cass River.

However, in the area immediately adjacent to the first farms, the opposing riverbanks were of unequal height. So the dam was constructed about a mile upstream, unintentionally determining the location of the village yet to come. The first local bridge was also built there, giving access to the south or Canada side, as it was known.

Even before the Cass River was harnessed by the dam, it served as a natural highway. In fact, the components of those first mills were transported upstream by scow from Saginaw. The mission journeys to the various Native American settlements were also primarily by canoe over the interconnected waterways, with missionary Friedrich August Craemer being accompanied by his faithful interpreter, Jim Gruet, whose mother was a Chippewa Indian.

Yet the relationship with the river was tumultuous. In the dry seasons, the flow was often insufficient to power the mills. In the springtime, the raging torrents threatened the existence of the man-made structures along its banks. It was more than a century after those first mills until protective dikes tamed the floods and safeguarded the business district.

Early commercial development occurred mostly by necessity. A brewery was essential, as were various mercantile establishments such as blacksmiths, wagon makers, harness shops, and clothing and grocery stores. The hotels, which much later formed the basis of the tourist industry, originally provided lodgings for the various itinerant salesmen.

One

THE PAST IS PROLOGUE

It has been said that history is written by the winners. Yet in the history of Frankenmuth, much of the early significance came from parties on the losing side.

In the case of the Algonquian Indians known as the Chippewas or Ojibwas, there is the further complication that their heritage was passed down orally, with the result that much has been lost. In the War of 1812, they really had nothing to gain, no matter which side won. The best they could hope for was to be left in peace on their ancestral hunting grounds. However, they allied with the losing side. The victorious Americans had more immediate interest in their lands than the defeated British ever did.

That interest was advanced through a number of treaties all under the threat that land not negotiated would be confiscated. Moreover, the concept of land ownership was foreign to Native Americans, which further disadvantaged them in the negotiations.

The Franconians were hereditary enemies of the Bavarians back at least to the time of Charlemagne, around A.D. 800. Then a thousand years later, the Corsican brigand Napoleon Bonaparte defeated an alliance that included the Franconians. To make matters worse, he rewarded his allies, the Bavarians, by making Franconia a part of the newly created kingdom of Bavaria. Just before the eventual defeat of Napoleon, Bavarian king Max Joseph expediently switched sides. As a result, he was allowed to keep Franconia and enforce a number of harsh social restrictions on its people.

All of this was against the backdrop of unprecedented social turmoil as attempts to replicate pre-Napoleonic Europe conflicted with emerging currents of rationalism and nationalism. The Industrial Revolution was replacing handcraftsmanship with cheaper manufactured goods, making the concepts of guilds and masters and apprentices almost irrelevant.

Therefore, at just about the same time, two proud cultures on opposite sides of an ocean found themselves under the domination of former enemies. They came to interact through the compassionate concern of a Franconian Lutheran pastor who resolved to make the Gospel of Jesus available to the dispossessed in the Saginaw Valley.

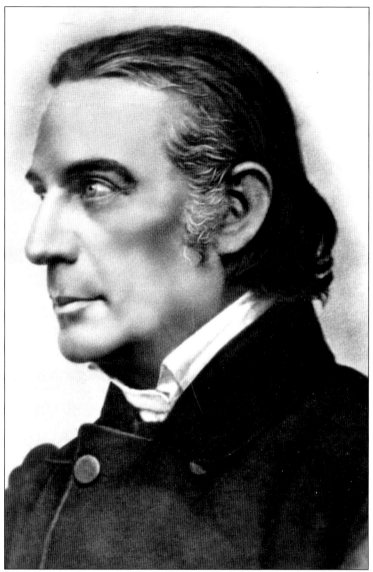

Pastor Wilhelm Loehe was an exceptionally gifted speaker and also keenly aware of the social injustices confronting the Franconian people. That combination was deemed potentially threatening by church authorities, who were directly responsible to the king. As a result, Loehe was posted to the obscure village of Neuendettelsau, where his influence would theoretically remain limited. But the authorities misjudged. During the remainder of his lifetime in that small village, he directed local efforts to address the sufferings of the handicapped, sick, and elderly. To that end, he established a *Diakonie* of 60 female students, which has evolved into the second-largest social institution in all of Germany. His mission efforts were even more impressive. He raised funds for missions, trained and sent missionaries, organized and funded seminaries, and founded a network of mission-cooperating parishes throughout Germany. He directed mission outreaches to Australia, Brazil, New Guinea, and the Ukraine, as well as North America, where he is considered the founding father of several Lutheran synods. Moreover, he conceived and sponsored the sending of the mission colony of Frankenmuth as well as many later colonies.

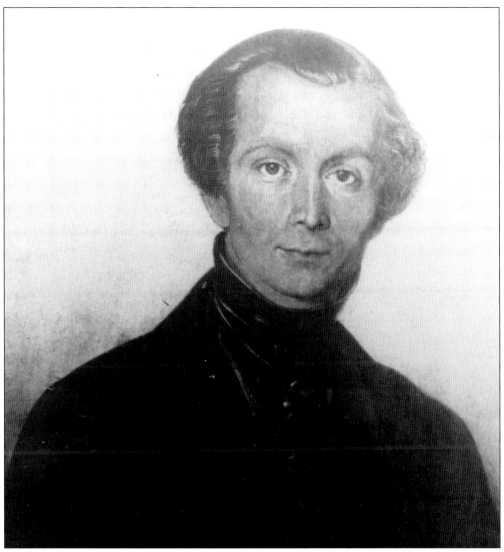

Friedrich August Craemer was a young firebrand who, while a seminary student in Franconia, participated in protests against the Bavarian government and in favor of a reunited Germany. Those efforts led to his being imprisoned and later being released only on condition that he leave the kingdom. While in exile, he served as a tutor for several noble families, eventually migrating to England where he tutored in the household of the daughter of Lord Byron. Later he accepted a position as instructor of Germanic language at the world-famed Oxford University. Upon hearing of Loehe's proposed mission colony, he risked returning to Franconia, where he completed his pastoral studies under Loehe's tutelage. He was ordained en route to the seaport of Bremen, where he assumed leadership of the colonists on their hazardous ocean voyage and further on to the banks of the Cass River.

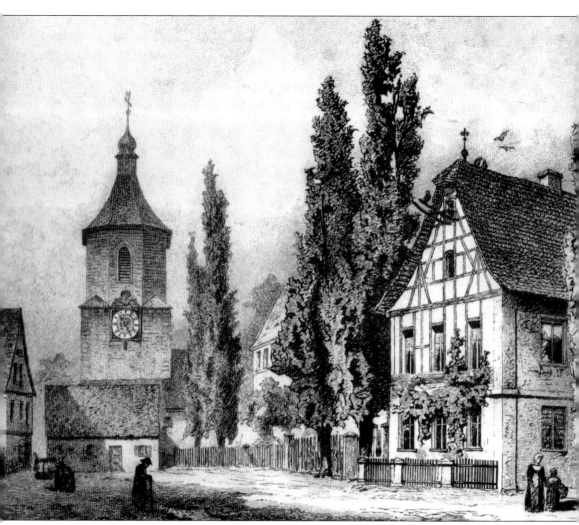

In the era before airplanes, trains, and automobiles, the rolling countryside of Franconia was dotted with small villages. Typically the farmers clustered their houses together within walking distance of their outlying farms, and the various supporting tradesmen and craftsmen established their shops and homes alongside the farmers. The prevailing religion, determined by generations-past conflicts, was Lutheran. Located within each village was a church, generally the most imposing structure, which befitted the piety of those times. Life was difficult, all the more so under the unsympathetic government of a Bavarian king. The Neuendettelsau church was named after St. Nicolai, and in 1837, a new pastor by the name of Wilhelm Loehe was appointed. Initially he was appreciated primarily for the beauty and inspiration of his sermons. But over the course of his service until his death in 1872, the village was transformed into a hub of social progress and mission outreach.

As with numerous other Franconian villages, the religion of the people of Rosstal was Lutheran. Generation after generation, they worshipped in their ancient church, named after the venerated early Christian martyr St. Lorenz. For most of those people, their small farms did not provide sufficient sustenance, so they supplemented their income with various crafts such as carpentry, weaving, shoe making, or blacksmithing. Under the harsh Bavarian social strictures, marriage was not permitted until a certain level of assets was accumulated. Only eldest sons could inherit, and businesses could not be formed without government permission. No wonder they clung so firmly to their faith in a better life to come. When a new pastor named Wilhelm Loehe was appointed in Neuendettelsau, several of the Rosstal villagers traveled the 11 miles to hear his wonderful sermons. And as his vision of a mission colony to the New World evolved, many of them volunteered to leave the scant security of their homeland to embark on a faith-based venture into the unknown.

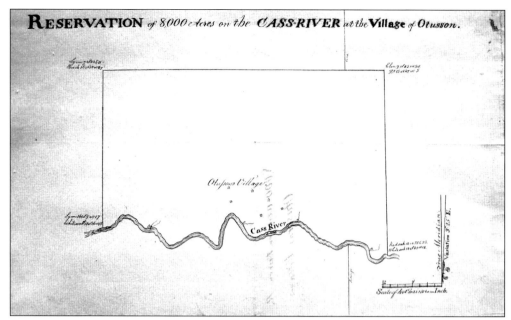

RESERVATION *of 8,000 acres on the* **CASS-RIVER** *at the* **Village** *of Otusson.*

By the 1819 Treaty of Saginaw, Gov. Lewis Cass negotiated six million acres of land from the Chippewa Nation. Minute portions of that acreage were reserved at the villages of the more important signing chieftains. One such was the 8,000-acre reservation at the village of Chief Otusson. Within two years of the signing of the treaty, a surveyor was dispatched to the wilderness to map out the boundaries of the reserve.

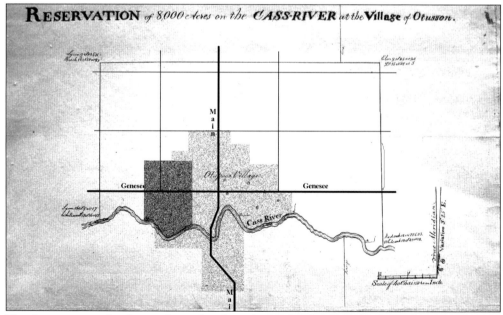

The former reserve lands were later placed on the market by the federal government at a price of $2.50 per acre, twice that of the surrounding acreage. That premium was to be remitted in compensation to the dispossessed Chippewas. In 1845, dealing with the federal land office, the Franconian settlers purchased 680 acres of what had been Chief Otusson's reservation. The overlay indicates present Frankenmuth, with the original purchase more darkly shaded.

Two

THE CHURCH

From the beginning, there was the church. In the earliest days, religious services were celebrated each morning and evening in a crude hut. Among the items brought by the first settlers were two large church bells, a processional crucifix, an oil painting of Christ on the cross, and iron altar ware. Beyond that, there were the individual family Bibles and Pastor Friedrich August Craemer's small library of religious books. The dedication to their mission intent was clearly and constantly evident even as they labored to carve their farms from the wilderness forest.

The first real church was a substantial log structure that served also as the school, the parsonage, and the communal meeting hall. As the community grew and prospered, first a frame church then later a large Gothic brick structure served as a worship sanctuary for the St. Lorenz congregation.

In 1880, a second Lutheran congregation, St. John's, was established by consolidating a village group with two smaller congregations from outlying areas to the north and south of town. For more than the first century of its existence, the Lutheran denomination was the only organized faith in Frankenmuth.

Yet the early isolation and the heritage engendered by the religious fundamentals created an attractive community. As the increased usage of automobiles made commuting more viable, many families employed in the larger surrounding cities established their homes in Frankenmuth.

Although most shared an appreciation of the local values, not all were members of the Lutheran faith. Thus the community welcomed, over a relatively short period, the erection of Methodist, Roman Catholic, and Bible churches. It is a tribute to their principles that all have contributed to maintaining and fostering the strong commitment to civic betterment.

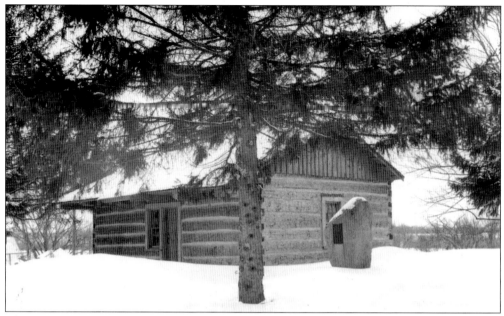

This is a reconstruction of the original 1846 cork pine log church and parsonage. The exact location was determined by excavating the remains of the original foundations. It is within the perimeter of the old St. Lorenz cemetery on the same ridge where the first clearings were made in the forest in 1845. A frame church replaced it in 1852, with the log structure remaining in use as the school.

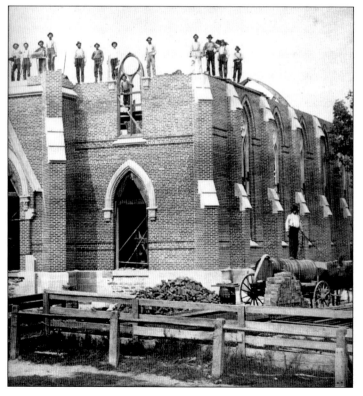

Some things are difficult to visualize in any but their completed forms. Yet even the St. Lorenz church was constructed one brick at a time. Moreover, back in 1879, the mortar was hand mixed and the construction materials were hoisted by horse-powered pulley systems. Even the water was hauled by horse-drawn tankers (right). (Courtesy of St. Lorenz Heritage Committee.)

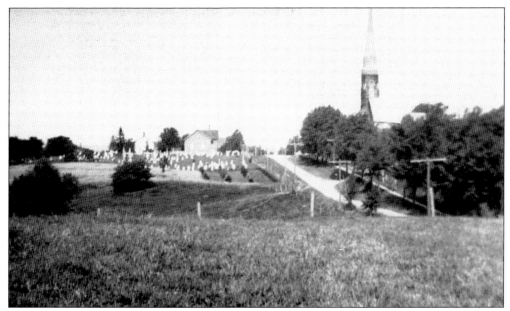

The configuration of the banks of the Cass River dictated that the dam, mills, and commercial area would evolve a mile upstream from the church. Directly across the street from the church is the old cemetery on the ridge where the first clearing was made by the original settlers. Note the tree-lined sidewalk that went up and down the hills from the village to the relatively isolated church.

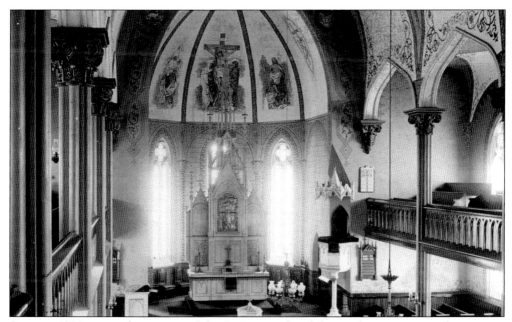

Since its 1880 origin, the interior of the St. Lorenz church has undergone many redecorations. In this early-1900s photograph, the oil-lamp chandeliers of the period are clearly evident. The hand-carved altar, dedicated as a thank offering in 1895, was specifically designed to incorporate an oil painting by artist Johann Enzingmueller. This painting accompanied the first settlers on their wilderness journey a half century earlier.

17

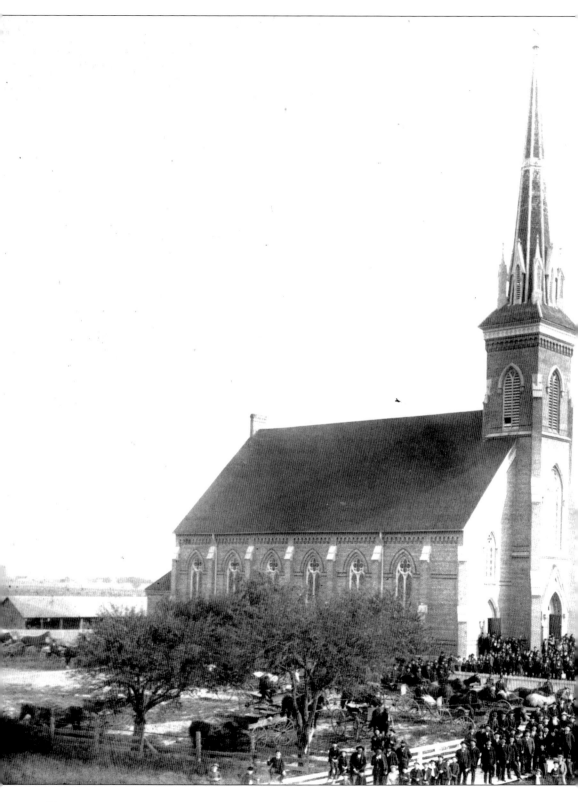

The massive St. Lorenz church was designed by Cleveland architect C. H. Griese in 1879. In the years immediately following the Civil War, Gothic Revival architecture, with its vast interior spaces meant to evoke visions of heaven, reflected a renewed national spiritual awareness. Congregational members were sent to inspect another of Griese's churches. There was much discussion before the final decision, with some fearing that the structure would be viewed as excessively prideful, but most saw it as an expression of thanks for their many blessings. Adjacent to the church is the impressive brick parsonage, capable of housing two families. To the rear are the extensive stables that sheltered the carriage horses from summer heat and winter cold during the lengthy services. Because of its fine proportions, photographs often do not do justice to the impressive grandeur of the church with its 167-foot steeple.

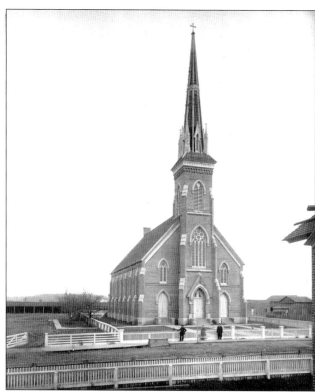

While there was much communal satisfaction at the 1880 completion of the monumental Gothic Revival structure, credit was reserved for God alone. Pastor (then professor) Friedrich August Craemer was present to preach at the dedication ceremony. The foreground fence bordered the old cemetery. Then came the road followed by another fence surrounding the church.

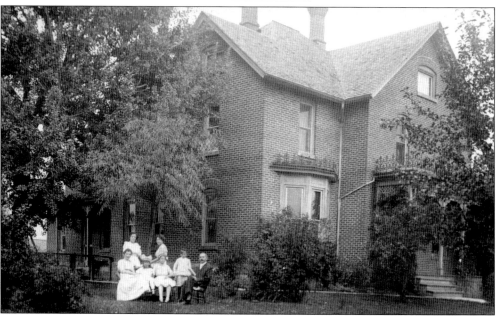

The impressive redbrick St. Lorenz parsonage just east of the church was a structure worthy of its surroundings. In this 1911 photograph, Pastor E. A. Mayer and his family are shown enjoying the beautifully landscaped side yard. Note the decorative wrought-iron railings over the bay window and porch. The structure was later deemed impractical and torn down before its historical value was fully appreciated.

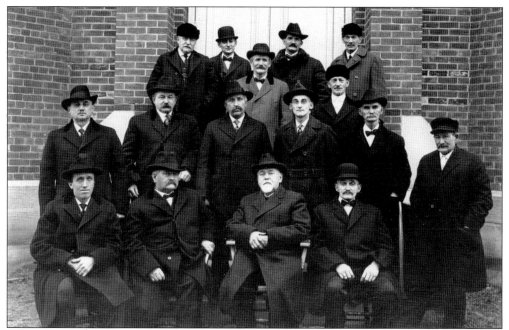

From its earliest days, the governance of the St. Lorenz congregation was a lay responsibility, with pastors being relegated to an advisory role. Shown here are the elders and trustees, notably all male and mostly elderly. These were elective positions of great respect, often entailing decades of service. (Courtesy of Wallace Weiss.)

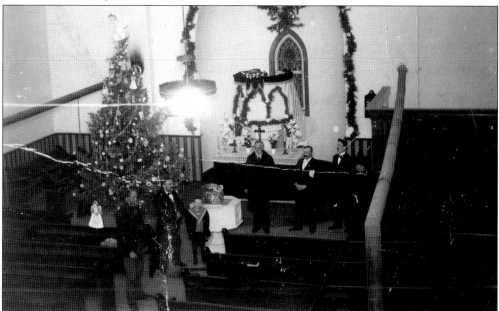

This is a very early picture of the interior of the St. John's church. Note the elevated pulpit in the center over the altar, the large baptismal font in the foreground, and the oil-burning chandelier suspended from the ceiling. A centrally located wood-burning stove furnished the heat, with the chimney exiting to the rear. The garlands and the decorated Christmas tree indicate the season.

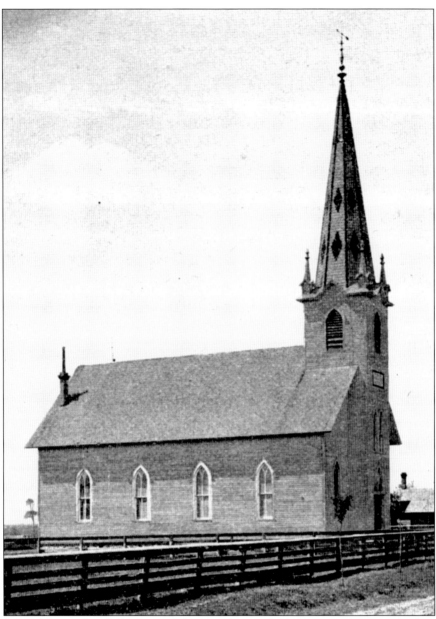

The beautiful frame church that served the St. John's Lutheran congregation was built in 1880. Located about one mile east of the St. Lorenz church, the street in front of both structures was then popularly known as Church Street but was officially called Tuscola Street. The St. John's congregation was formed by a consolidation of Bethel Church to the north of the village, St. Paul's Church to the south of the village, and a number of former St. Lorenz members. At the time of St. John's construction, the village of Frankenmuth was a narrow strip to either side of Main Street, so the church's location, one block to the west of Main Street, was still farmland. At the very foot of Franklin Street, the church seemed to be perfectly situated, but it was damaged beyond repair by a tornado in 1996. Many artifacts of the frame church have been preserved and incorporated into the new brick St. John's church located east of town on Genesee Street. (Courtesy of St. John's archives.)

Three

AGRICULTURE
AND LOGGING

The native inhabitants of the area were primarily hunters and gatherers, relying on what nature freely provided. The only attempts at cultivation depended on the women, who occasionally planted small plots of the "three sisters"—maize, squash, and beans.

For the settlers, the livelihood of their families and their mission depended on farming. In their homeland, most of them had garden plots of not much more than an acre. They earned their livings as craftsmen—weavers, carpenters, blacksmiths, or shoemakers—all worthy skills but of limited value in their new environment.

The first and most formidable obstacles were the trees, some with diameters exceeding the spans of crosscut saws. As the trees were felled, some of the logs were employed in construction, furnishings, and firewood. The more magnificent specimens, particularly the hardwoods, were too large to move and so were burned where they fell.

As the growth of America burgeoned westward, there was an ever-increasing demand for building materials, primarily lumber, which transformed the previous nuisance into green gold. It was an ideal situation where the farmers could work in the woods in the winter season, simultaneously clearing additional farmland while producing a source of hard cash that could then be used to purchase additional acreage of the seemingly endless surrounding forests.

Large families were the norm, and there was a steady influx of relatives and friends from the home villages in the old country. Over the generations, the devotion to well-kept farms and hard work ensured the growth and prosperity of the community.

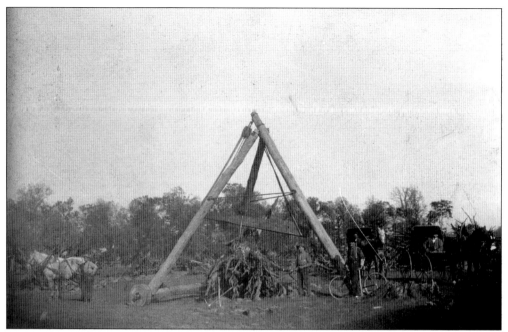

Confronting a difficult problem is often referred to as being stumped. The ingenious application of pulley systems, as shown here, helped solve the problem. Note the spectators in the buggies and one man employing a primitive bicycle to reach the scene. In later years, dynamite was frequently employed to literally blast the recalcitrant stumps out of the ground.

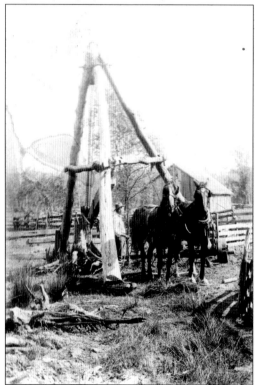

Long after the trees were felled and processed, the stubborn stumps remained an obstacle to farming. Here horses Jim and Charley are hitched to the leverage of a stump puller on the Nickless farm. Once pulled, the stumps were sometimes dragged to the edge of the field and interwoven to form a fence.

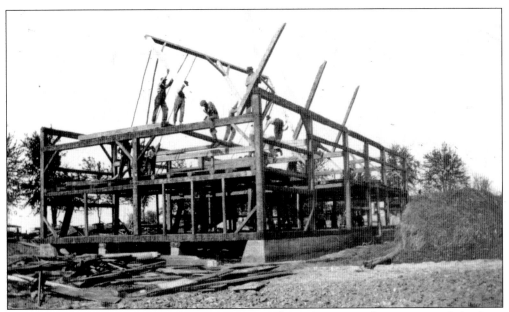

One of the clearest examples of community interdependence was the occasion of the barn raising. The marvelous wood beams and the skill of the men who joined them together produced structures whose usefulness and beauty have survived the generations. A typical siding was hemlock boards, which weathered into beautifully intricate wood-grain patterns.

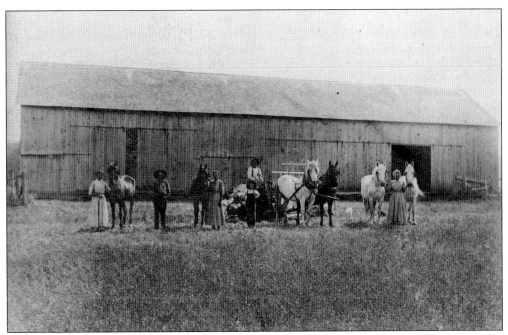

The heavy soil of area farms produced bountiful crops but only with considerable effort. The farm's draft animals provided the horsepower essential to the task. Here the Ziegler family proudly displays its well-kept horses. The structures to the rear housed the animals as well as some of the equipment they pulled.

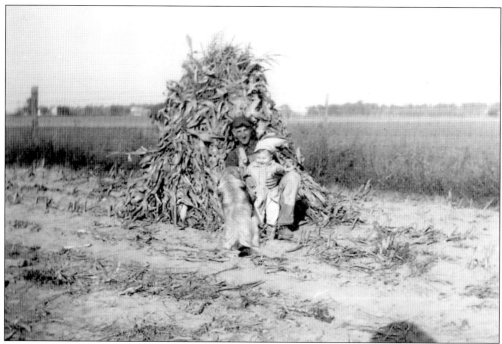

This depiction of a farmer and his son with their dog in front of a corn shock captures the essence of Frankenmuth's agricultural heritage. Love of the land and good stewardship of it are traditions passed down through many generations. Many of the farms that were cleared from virgin forests remain with the descendants of those first pioneers. (Courtesy of J. E. Bickel.)

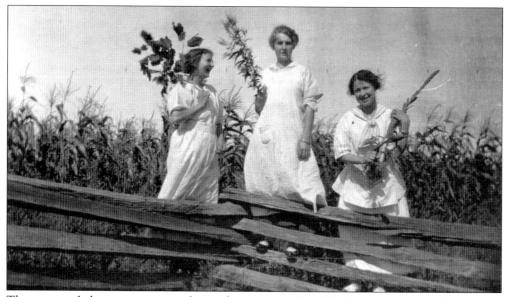

These young ladies are enjoying a breezy late summer day. While young people of both sexes were expected to help in the fields, these girls are not dressed for such work, although the plants they are holding would classify as weeds. Note the sturdy split-rail fencing surrounding the cornfield behind.

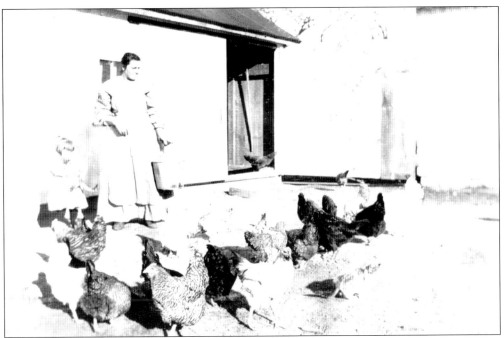

Caring for the chickens was typically designated as a female task. Long before the famous chicken dinners became a tourist attraction, farm families enjoyed Sunday banquets featuring their own poultry. Eggs were also a much-enjoyed staple of the farm diet. Margaretha (Maggie) Grueber and her daughter feed their flock in this 1920 photograph.

Despite the passengers' garb, it is unlikely that the heavy-duty farm wagon was actually used for Sunday transportation. Note the heavy wheels and lack of suspension that would have made for a disconcertingly bumpy ride to church. Most farms had several vehicles specifically designed for particular usage. Going to town normally involved a carriage or buggy.

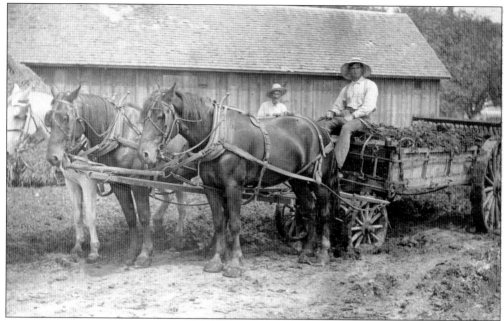

Although the earliest ground breaking required the brute strength of oxen, horses provided a much more flexible alternative. Just as with well-kept buildings and well-maintained farmland, there was pride in well-groomed animals. As more sophisticated machinery became available, the horses adapted. This three-horse hitch is pulling a fully loaded manure spreader.

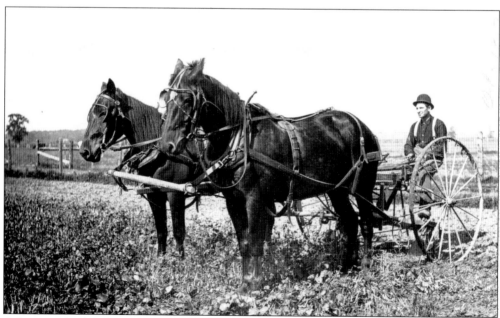

A farmer in his bowler hat prepares to begin cultivating his field. Among the earliest established Frankenmuth businesses was livestock trading, with many advertisements appearing in regional publications. Just as farmers today take pride in their shiny tractors, the farmers of yesteryear had a true affection for their draft animals.

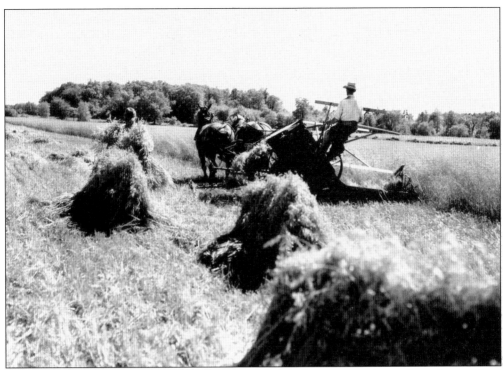

From biblical times on, grain had been harvested by hand, cutting single swaths with a sickle or scythe. But the invention of the horse-drawn reaper greatly simplified the task. This implement cut, bundled, and tied each sheaf, requiring only that they be stood up in the field for final drying. Here G. Henry Weiss is shown harvesting the bountiful crop on his Junction Road farm. (Courtesy of Mary Nuechterlein.)

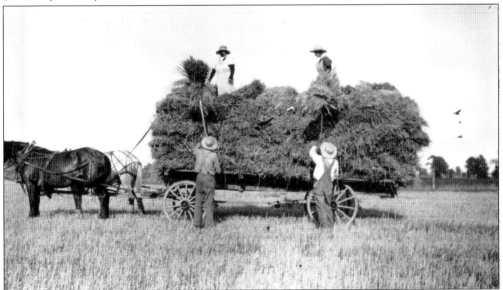

Even after the introduction of time-saving tractors, many farmers continued to prefer horses for particular tasks. Workers on the Reindel farm in this late-1920s photograph load sheaves for a trip to the barn where they would be threshed.

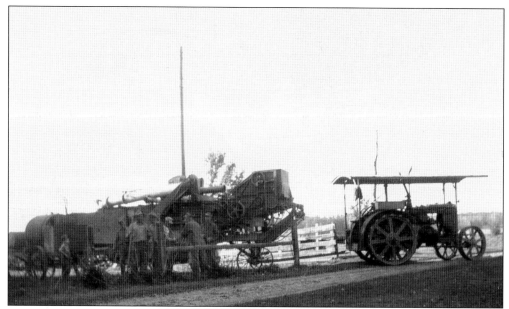

Neighborly cooperation at harvest time was more than mere convenience. It was a necessity. When threshing machines became available, neighborhood cooperatives were formed to finance the purchase, with the crews going from farm to farm. The steam traction engine (right) was connected by a long belt to drive the thresher. Note the water wagon (left) needed to refill the boiler on the tractor, which provided the steam. (Courtesy of Mary Nuechterlein.)

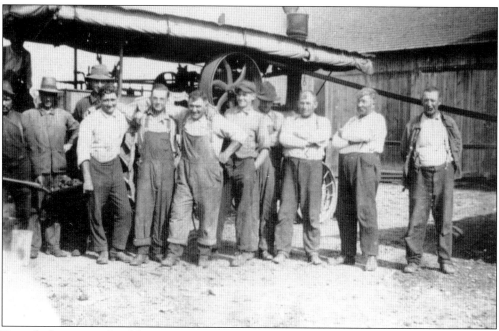

From the beginning, local farmers cooperated during some of the critical harvest periods. Initially it was a matter of survival, but the practice continued as labor-saving devices became available. A threshing machine was impractical and likely unaffordable for individual farms. This typical crew stands alongside the steam engine. Note the drive belt going off to the right.

As more modern agricultural methods and equipment became available, they were eagerly adopted but only after they were proven in practice. One farmer gave something a try and, if successful, spread the word immediately throughout the closely knit community. Even today, the best advertisement is a neighbor's recommendation. (Courtesy of J. E. Bickel.)

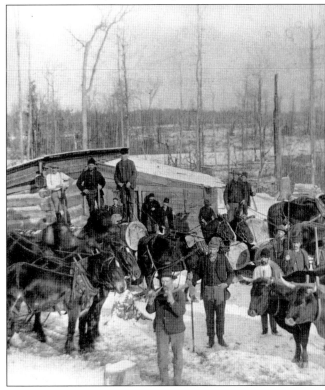

This photograph of a Cass River logging camp shows the horses and oxen that hauled the logs over ice-covered paths to the banking grounds along the river to await the spring floods. Once their own lands were cleared, several Frankenmuth men worked camps like this during the winter nonfarming season.

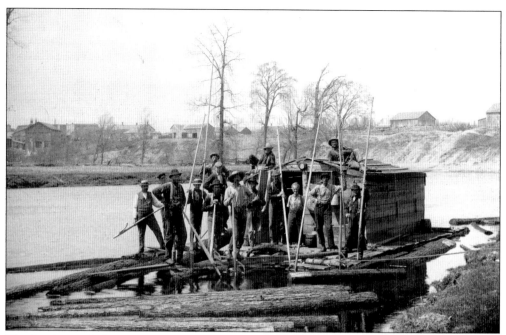

The floating cook shanty, or wanigan, was essential on the river drives. The long pike poles held by some of the shanty boys were used to free up the frequent logjams that occurred at bends in the river. The shorter tools were peavies and were similarly employed. In the background on the high banks are some early Frankenmuth buildings.

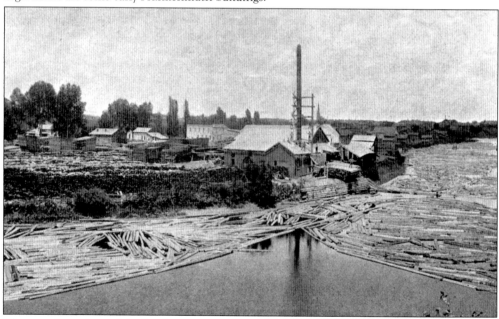

The very finest logs of the lumber era were Cass River cork pine. Local tradition says that the largest pine ever felled in Michigan was from the Ziegler woods less than two miles upstream from the Hubinger sawmill. The periphery of the booming pen in the river was formed by chaining logs end to end. Each of the incoming logs bore a distinctive log mark to identify its owner.

Four

THE RIVER

The Cass River was previously known as the River of the Hurons and prior to that as the River of the Onottoways. It meanders in a generally southwesterly direction, draining the Thumb of Michigan down to its confluence with the Flint, Shiawassee, and Tittabawassee Rivers to form the Saginaw River.

Circuit rider Friedrich Schmid of Ann Arbor, the first Lutheran pastor in Michigan, made the initial recommendation for the eventual site of Frankenmuth to be located on the high banks of the Cass River about 15 miles southeast of the frontier settlements of the Saginaws. His primary consideration was that the river would be a means of transport for the mission trips to the many Chippewa settlements along its connecting waterways.

It is unlikely he anticipated that some of the richest farmlands in the world lay hidden beneath the formidable forest covering those banks. Yet the presence of those Native American villages was a clear testament to the many natural benefits of their location.

For the Franconian settlers, the river proved to be a mixed blessing. Pastor Friedrich August Craemer did make many mission journeys by canoe, some to villages as far as 75 miles distant. The river eventually provided waterpower for a gristmill and a sawmill as well as a means to transport logs to be converted to lumber by the Hubinger mill. In the winter, ice was harvested and stored to provide refrigeration for the warmer months.

Yet the river was an unreliable ally. In the dry season, the flow was often insufficient to power the mills, and the spring torrents rushed down between the high banks, swamping the structures and disabling the equipment. As the commercial village evolved in proximity to the mills, it too suffered near-annual flooding until the construction of protective dikes more than a century later.

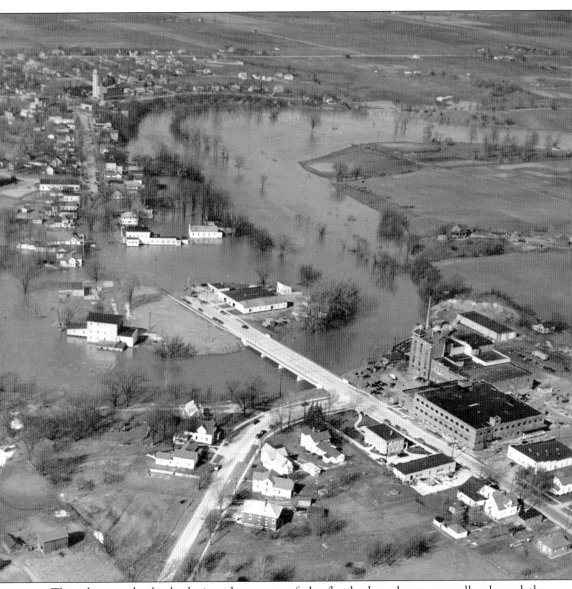

This photograph clearly depicts the extent of the floods that almost annually plagued the village. From the Hubinger mill (left, center), Main Street extends uphill northward to the Star of the West silo near the Tuscola Street intersection. The heart of the modern tourist area is clearly underwater, and it was a formidable task to clear out the river muck left behind when the floods subsided. Typically the floodwaters carried the ice floes over the Hubinger dam, but the many bends and shallow depths approaching Bridgeport downstream caused the jams that then backed up the waters. Moreover, the eventual outlet, the Saginaw River, is so level that northerly winds often caused it to flow upstream, further delaying the exit of the floodwaters. (Courtesy of Wallace Weiss.)

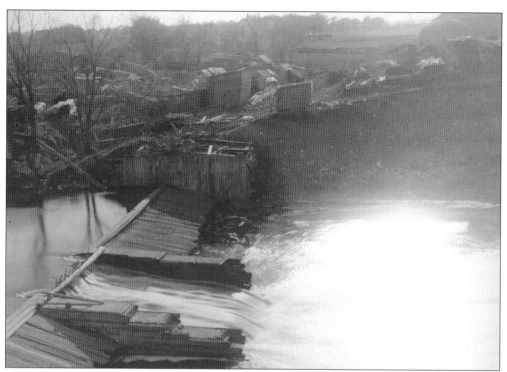

This early picture clearly depicts the wooden construction of the first dam across the Cass River. On the south bank was the Hubinger sawmill and lumberyard. The single-bladed saw took considerable time to process each log, and the river often provided insufficient power during the dryer seasons. This mill was replaced by a steam-driven version a bit farther upstream on the north bank.

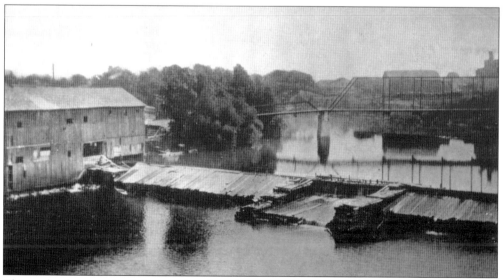

This early photograph of the wooden dam shows its relation to the spillway that powered the stone wheels of the Hubinger gristmill (left). The central, more vertical portion of the planking could be removed to lessen potential damage during flooding. The iron Main Street bridge is visible just upstream.

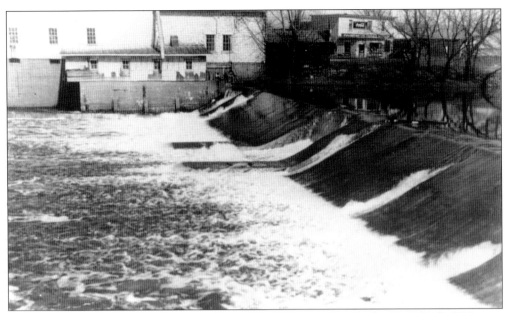

The earliest dam across the Cass River was constructed in 1847 to provide power for the Hubinger gristmill and sawmill. On those same wooden foundations, a much more substantial concrete structure was later built. The cooperative Frankenmuth Milling Company is depicted here (left) with some of the businesses on the east side of Main Street visible as well (right).

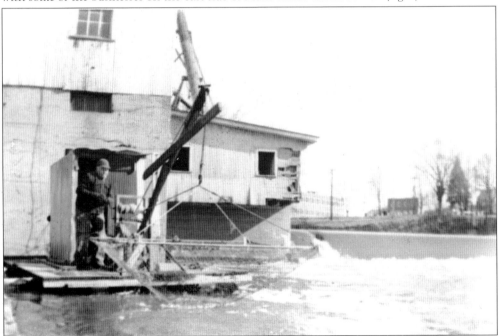

One reason the Native Americans favored riverside locations was the abundance of fish. The early settlers also enjoyed this bounty. Every spring, as the floodwaters subsided, suckers undertook their upstream spawning run. Blocked by the dam, they accumulated in such concentrations that they could easily be dipped by square nets affixed to onshore booms. The picture above shows the process, with the Hubinger mill in the background.

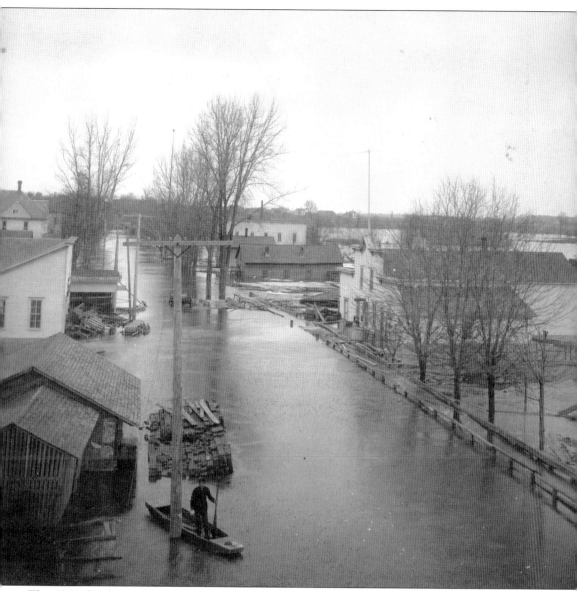

The 1904 flood was among the most extensive. In this picture, the almost obligatory "man in the boat on Main Street" is shown. From a relatively safe post-dike perspective, it is easy to question why the community stoically suffered year after year from springtime floods. Yet back then, high waters were accepted as just one of the less pleasant aspects of a natural cycle. Another difficulty was that there was no clear government entity to address the problem. While all suffered inconvenience, the actual damages were generally limited to the floodplain area. It was not until the developing tourist business there generated more substantial cash flow and the village and township governments could see the need to cooperate that the problem was solved. It is a testament to the sturdy construction of some of those downtown buildings that they suffered repeated flooding without losing their structural integrity.

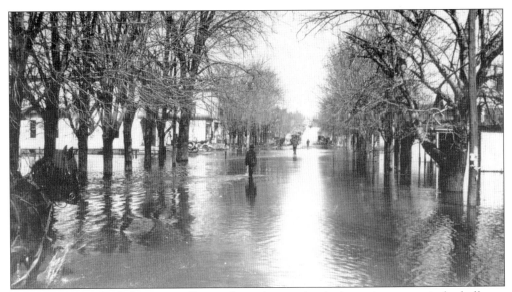

Facing north up the hill on Main Street, these three individuals are in progressively shallower water. The horse is still up to its knees. Although the homes and businesses shown appear mostly above water level, all had basements whose contents were evacuated or ruined, and the flooding was always a sudden event without any means of advance warning.

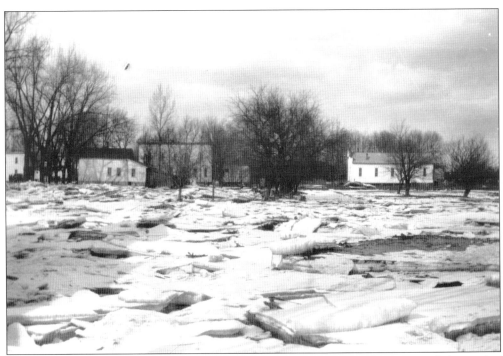

In the spring of 1926, the annual breakup of the river ice was followed by an extended period of extremely cold weather, resulting in the refreezing of the huge ice floes just above the dam. The ensuing flood forced the additional downstream-moving ice chunks well up along Main Street, causing substantial additional damage.

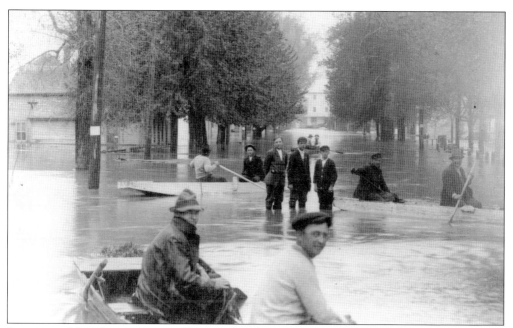

Boating on Main Street was actually not a popular pastime, as might be assumed from the many flood pictures passed down through the generations. Here is yet another, looking down the Main Street hill toward the south, with the Hubinger mill in the center. The relative age of the photographs can be roughly estimated by the size of the trees that line each side of the street.

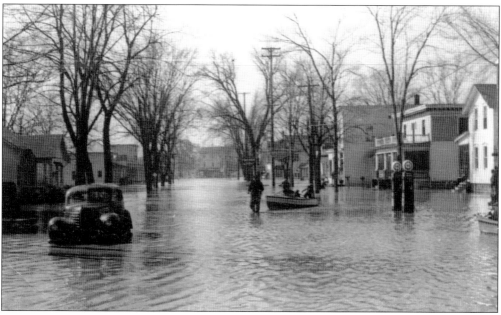

One springtime flood was pretty much like any other, with the only variable being the height of the water. However, each brought with it unique damages and a massive ensuing cleanup. In this 1940s flood, the waters rose higher than normal. Most of the flood pictures were taken from the higher ground north of the river, looking back south along Main Street. Note the curbside Pure gasoline pumps (right).

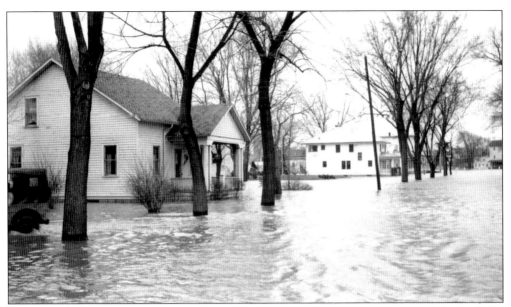

Floods were a near-annual occurrence as the ice breakup clogged the river channel just as the spring rains commenced. This scene is Main Street looking south. The Hubinger mill, on the river's bank, can be seen to the extreme right. Note the elegant, large trees that lined both sides of the street at that time.

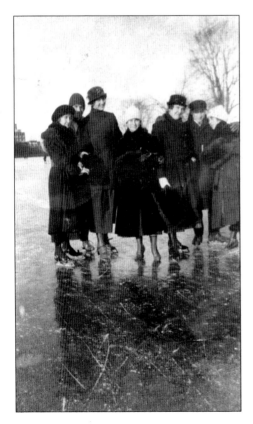

These young ladies are obviously enjoying their skating outing on the Cass River near Hubinger's Grove. To the far left is the Star of the West mill. Other skaters can be seen in the background downstream. Sometimes the impromptu skating rink was demolished when blocks of ice were harvested to provide cooling for the summer months.

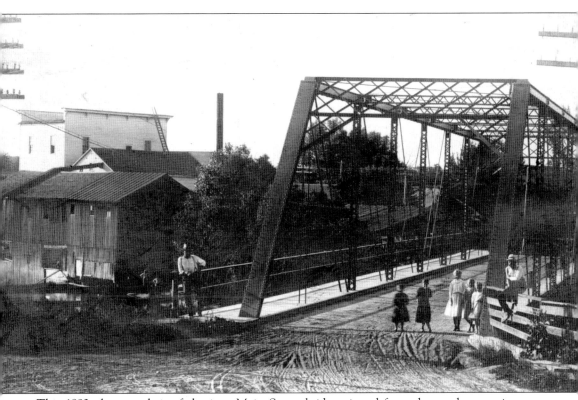

This 1893 photograph is of the iron Main Street bridge viewed from the south, or as it was locally called, the Canada side of the river. One of the interesting local mysteries is why Canada was deemed to be in a southerly direction. Main Street, across the bridge, curved sharply to the left, passing the large white gristmill building. Note on each side the arms of the telephone poles. Before the first wooden bridge at the same site, cross-river transport was done by means of a rowboat, which seemed to be invariably on the wrong side of the river. Frankenmuth's first architect, Johann Adam List, arrived in 1846. In 1857, he posted a sign-up sheet in which any male citizen interested in having a bridge could commit to either money or labor for the project. It is an affirmation of the communal spirit of those times that the bridge was completed that same year.

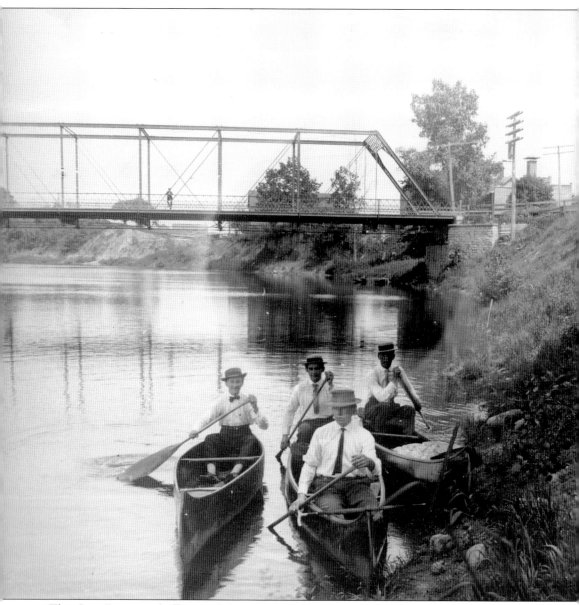

The Cass River is ideally suited for canoeing. The current runs generally to the west, and prevailing winds are from the west as well, making it possible to navigate easily in either direction. Missionary pastor Friedrich August Craemer and his interpreter, Jim Gruet, employed canoes to visit the Chippewa villages along the connecting waterways.

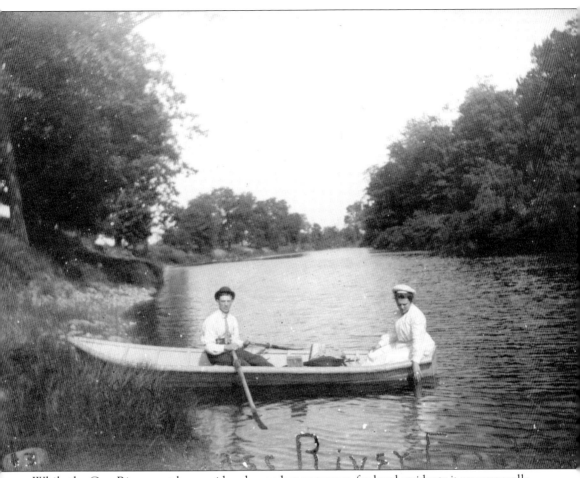

While the Cass River must be considered a modest waterway, for local residents it was generally much appreciated, except in times of flooding. The wooded banks along its meandering course provided a natural sanctuary, even in those less hectic times. Here a well-dressed young couple shares a solitary outing in a rowboat, with a picnic basket safely tucked onboard.

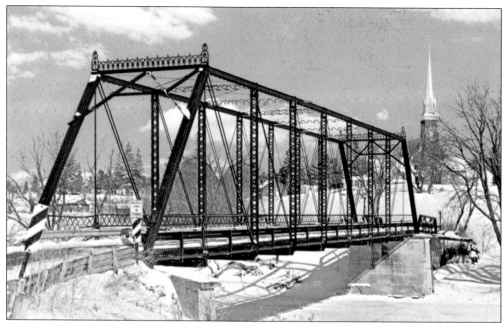

This picture of the Dehmel Road bridge, or "Black Bridge," clearly shows its proximity to the St. Lorenz church (right). While the commercial nexus of the village was on Main Street a mile east upstream, clearly the residents of the south side farms appreciated the improved access to their house of worship.

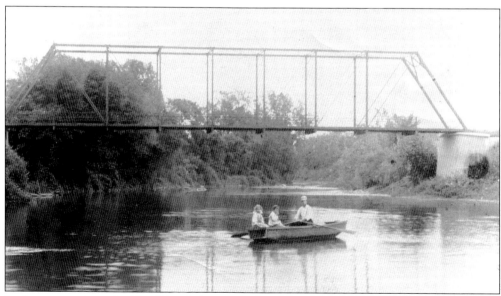

In the summertime, the Cass River below the Dehmel Road bridge was scarcely deep enough to float the rowboat pictured here. Nonetheless, the trio in the boat seems to be enjoying its outing. Because of its glacial origins, the depth of the river varies considerably, with the deepest portions generally to the outside of its many bends.

Five

EDUCATION

Among the first 15 settlers, there was only one child—six-year-old Henry Craemer. His mother, Dorothea, the pastor's wife, must be credited as the original teacher. When the second group of Franconians arrived the following year, there were many families with children. Beyond that, more than a dozen Chippewa children shared the humble log parsonage to receive instruction.

Thus the initial schoolhouse was also the parsonage, church, dormitory, and communal meeting hall. Even after a frame church was constructed in 1852 and the pastor was settled in more proper accommodations, the sturdy cork pine log structure continued to be used as the school.

But as more families came to establish their farms, the community inevitably expanded in ever-wider circles from its original location. To maintain education within reasonable walking distance of the students, additional one-room schoolhouses were established. For more than 50 years, all local education was under the auspices of the St. Lorenz congregation, with a final tally of nine separate schools in operation.

Shortly after 1900, the state asserted its responsibility in the education process. This resulted in the rather curious situation of one-room public schools being constructed, often directly adjacent to the established parochial schools.

While the commitment to formal education was resolute, it was also generally acknowledged that eight years of it was sufficient, except for prospective pastors and teachers. With the advent of the automotive era, busing of students became a possibility, and it was decided to consolidate the St. Lorenz schools at a central location in the village.

As the community inexorably became less isolated, the need for additional years of local schooling became evident. First a two-year high school and then, later, a full four years were provided. The quality of education, whether parochial, public, or combined, has always been fortified by public and parental commitment. Whether remaining at home or venturing into the wider world, the students of Frankenmuth were well equipped.

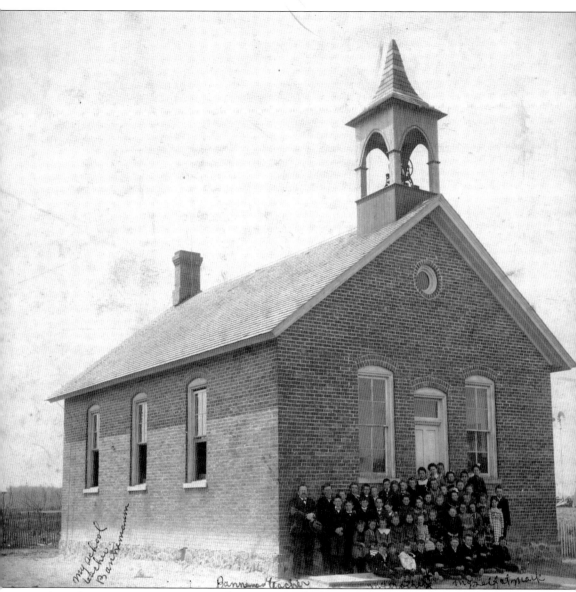

As with many immigrant groups, education was a high priority. For more than a half century, it was solely the responsibility of the St. Lorenz congregation. In the preautomotive era, one-room schools were established within walking distance of the students. This Northwest District schoolhouse was one of nine simultaneously operating under church sponsorship. Some of the classes, such as religion, were conducted in High German, considered more proper than the Fränkisch dialect commonly spoken by the students and their families. Other classes were taught in English, and for many students entering the first grade, it was their first exposure to that language. In the Northwest District, a public school was later erected immediately adjacent to the parochial school. The first public-school teacher there was a young girl, only about 16 years old, and she boarded with the parochial teacher's family in the congregation-furnished home, sharing a bed with that teacher's eldest daughter. Government regulations were always scrupulously observed, even if not necessarily welcomed.

46

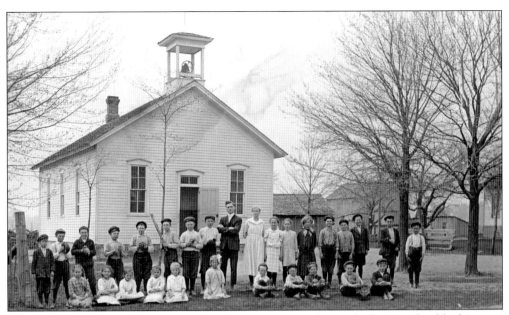

The St. Lorenz system of one-room schools was unique in that each district school had its own board and was semi-independent. This photograph of the Southern District shows the typical variation of students in grades one through eight, with the boys ready for a recess baseball game. A few generations later, teacher E. F. Rittmueller (center) had the Frankenmuth public middle school named in his honor.

This St. Lorenz Eastern District school is typical of the nine that served the congregation's students. The brick chimney conveyed the smoke from a single potbelly stove, which unequally heated the entire structure. Note also the ornate bell tower. At the completion of the eighth grade, students had heard the individual lessons eight times.

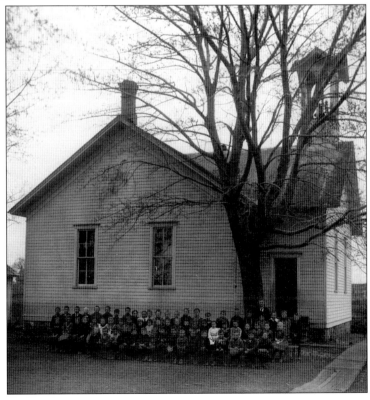

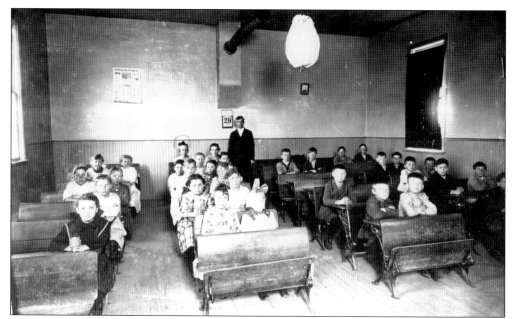

This picture illustrates the sparse interior of a typical St. Lorenz one-room schoolhouse. The stovepipe led to a potbelly stove toward the front of the room near the teacher's desk. The walls remained bare except for two calendars and a small framed picture of the church. While the classroom was coeducational, the sexes were strictly segregated as they were in the church services of that era.

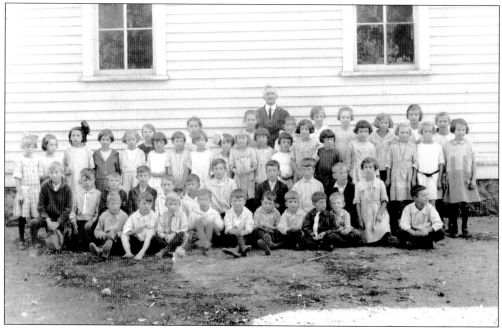

The Eastern District of the St. Lorenz school system was located on Main Street in the village. Unlike all the other one-room school districts, this had two schools, with students segregated according to age. The primary grades, one through four, depicted in this photograph, were taught by Herman Meyer.

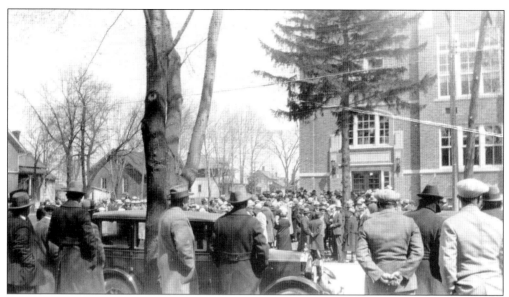

In 1928, the availability of motorized school bus transportation made it possible to consolidate the St. Lorenz educational systems. Teachers from the former one-room schools were reassigned, with each being responsible for a specific grade. The new three-story brick schoolhouse, centrally located on Main Street in the village, maintained and improved the tradition of educational excellence. Depicted here is the April 15 dedication ceremony.

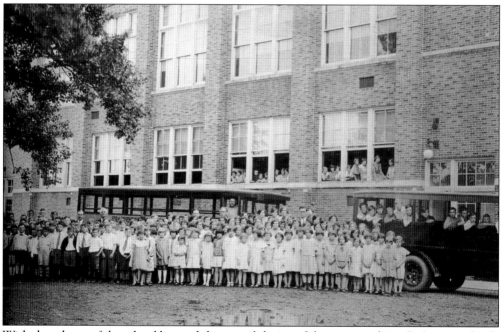

With the advent of the school bus and the consolidation of the many outlying St. Lorenz schools into a central village location, this late-1920s picture captures the students in front of the newly constructed school. Note the near uniformity of the girls' dresses, while most of the boys still wear knickers.

In this early picture of the St. Lorenz consolidated school, the trees to the front are noteworthy, as they must have been preserved during the construction process. The newer plantings of trees to the side and the bordering hedges provide contrast. Even the large structure shown was later substantially expanded to the right.

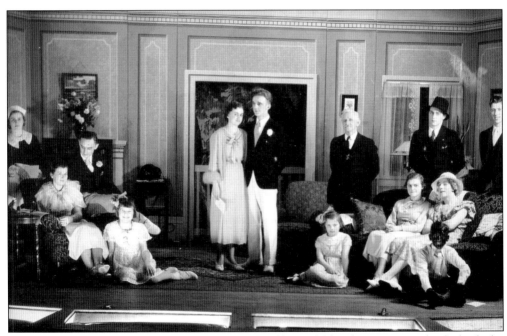

In the era before television and with movies not locally available, plays were popular for both the participants and audiences. This 1935 production was under the auspices of the Young People's Society but features cast members from across the age spectrum. The older gentleman is teacher Herman Meyer of the St. Lorenz faculty, who served as advisor to the group.

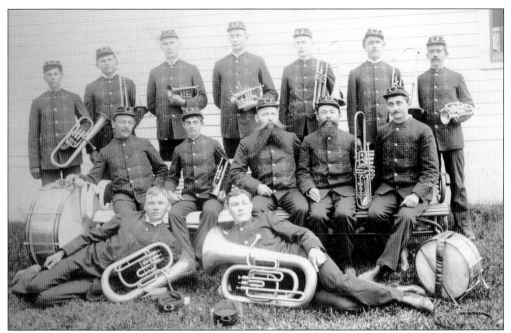

The musical heritage of Frankenmuth is rooted in the tradition of the Lutheran church. Singing was taught in every one-room schoolhouse, and many hymns were memorized. The numerous choral and instrumental groups that evolved served also as social clubs. The military influence after the end of the Civil War is reflected in this picture of the 1890s Frankenmuth Band.

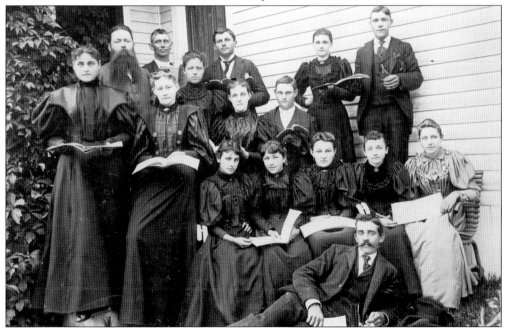

At any given time, there were many varied musical groups in existence. The man in the upper left with the magnificent beard is teacher Ernst Strieter, who also appears in the previous picture, and the group is the St. Lorenz Western District Singverein (choral society). Note the Sunday best clothing from around 1900.

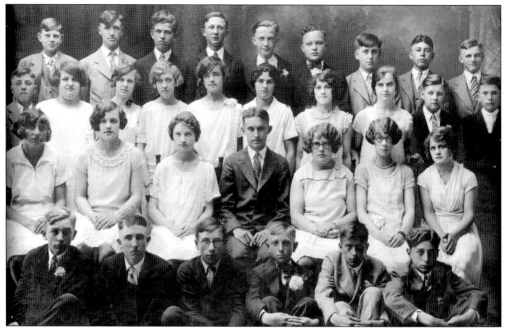

Graduations at any level were celebrated quite formally. This is an eighth-grade class photograph from 1928. Many of the boys sport flowers on their suit lapels. Some of the white-clad girls have had their hair marcelled for the occasion. In 1928, any students wishing to pursue further education faced a daily 30-mile round-trip to Saginaw.

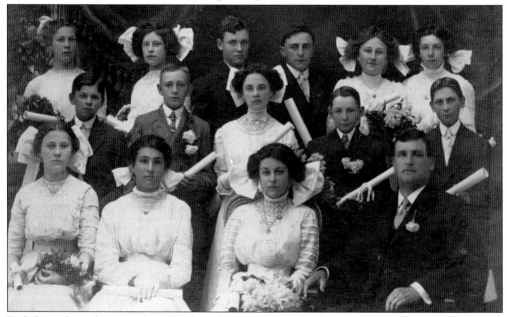

Eighth-grade graduates in this 1910 class photograph proudly clasp their recently earned diplomas. Note the abundance of flowers to commemorate the occasion. For most, this milestone marked the end of formal education and a transition to more adult responsibilities. The young men worked on the family farms or in the family businesses. The young ladies continued to assist their mothers.

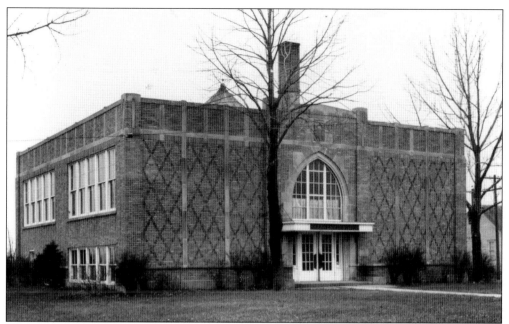

For much of its history, an eighth-grade education was deemed sufficient for Frankenmuth students. Girls learned domestic skills from their mothers, and boys generally followed in their fathers' occupations. In the wake of World War I, by the early 1920s, the need for additional schooling became apparent, and the pictured high school was built to add 9th- and 10th-grade curricula.

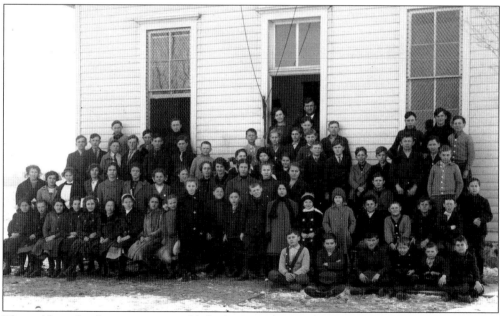

The public school system was established in Frankenmuth just after 1900. Just as with the St. Lorenz schools, it functioned through several one-room schoolhouses. Generally the schools were popularly referred to by the names of the presiding teachers. This was called the Hendrick School and was located on Genesee Street, part of the area now occupied by the modern Frankenmuth public schools.

As the community evolved beyond its agricultural roots, additional education became a necessity. This 10th-grade graduation class from the early 1930s shows the emphasis given to academic achievement. Many went on to complete an additional two years at Arthur Hill High School in Saginaw and even further formal education beyond that. But their early Frankenmuth education provided a sound basis.

Although the public school system terminated at the 10th grade in 1928, the tradition of excellence in student athletics was already evident. Regardless of league, the Frankenmuth teams then, as now, provided formidable opposition. Community pride and support were demonstrated in the facilities, equipment, and attendance at games. Local teams have brought back awards and trophies sufficient to justify those high expectations.

Six

ARCHITECTURE

Early architecture was indeed primitive. With instruction from missionary Auch from Sebewaing, log cabins were built with the sole purpose of providing quickly available shelter on the lands that were being cleared for agriculture. Similarly, as livestock was acquired, crude huts provided them minimal protection from the elements.

The sawmill was an early priority, and the first carpenter-architect-builder, Johann Adam List, arrived with the second immigrant group in 1846. Within a dozen years, a bridge spanned the Cass River, a frame church housed the congregation, and substantial, even decorative farm homes, barns, and schools sprang up across the countryside.

The pride in well-kept lands and fences extended to buildings, and there was an urgency to replace mere shelter with more comfortable and attractive structures. An often remarked trait of the Franconians is their work ethic. But they also have a tendency to employ the prosperity of those efforts toward meaningful progress.

The most obvious example is the St. Lorenz church that was erected in 1880, barely more than a generation removed from the log cabins. The monumental redbrick structure, then capable of seating 1,000, was designed by C. H. Griese of Cleveland, a leading architect of the Gothic Revival movement. It remains as a testament to both the faith and foresight of those early members, still serving the spiritual needs of their descendants.

As the commercial hub of the village extended up the hill to the north of the mills, both the business buildings and their owners' residences reflected the solidity and prosperity of the growing community.

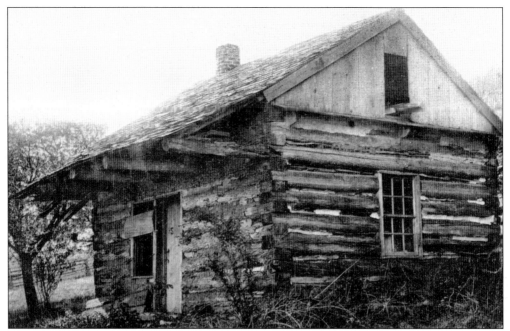

The earliest residences were constructed of the most plentiful material, hand-hewn pine logs. The roofing consisted of split-cedar shakes. The very limited amount of millwork, including the glazed windows, was brought in from the neighboring village of Tuscola or even from Saginaw until a local water-powered sawmill was established in 1847.

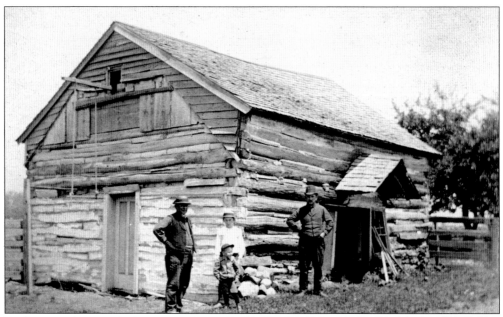

By the time photography became widespread after the Civil War era, most of the local log cabins were replaced. Those that remained were generally utilized for storage rather than as residences. Note the interesting boom and pulley arrangements here, which hoisted heavy or bulky objects to the loft area. The cedar shake shingles appear somewhat worse for wear.

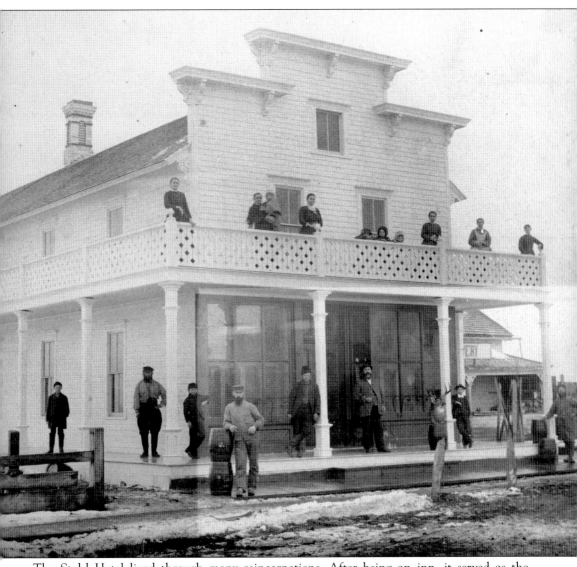

The Stahl Hotel lived through many reincarnations. After being an inn, it served as the residence and offices of Dr. George Schmitt, the local dentist. Still later, it housed the municipal government offices before being transformed into a gift store. It was recently demolished to make way for the Marv Herzog Hotel. Perhaps time does flow in circular currents. Many of the older buildings in the community passed through varied uses. There was a natural reluctance to demolish any structure that might serve a useful function, even though not the one originally intended. That same frugal philosophy also often resulted in moving substantial structures from one location to another. Of course, this had the unintended consequence of historical preservation. There is now an increased awareness of the value of preserving history for its own sake. Note the large kegs awaiting transport into the taproom, with the ladies posed above and men below.

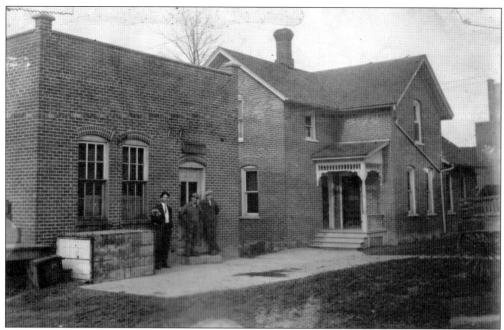

The *Braumeister*, or master brewer, held a position of considerable local prestige, as can be seen by this picture of his house, adjacent to the Frankenmuth Brewing Company (left). That business prospered, converting to malt extract production during Prohibition and back to brewing thereafter. To accommodate one of many brewery expansions, this substantial brick home was eventually moved intact to Jefferson Street.

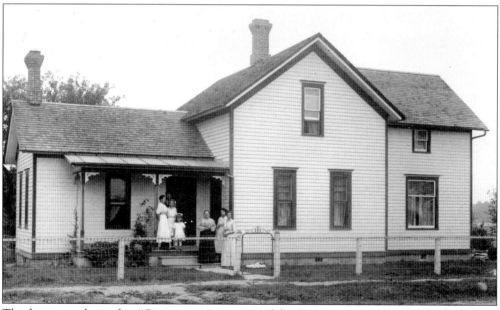

This house was located in "Georgetown" just west of the St. Lorenz church, so called because of the many men named George who resided in that area. The fenced yard and ornate trim were typical of the early 1900s. The brick chimney to the left likely served a kitchen stove, while the one in the center was for the parlor stove, responsible for heating the rest of the house.

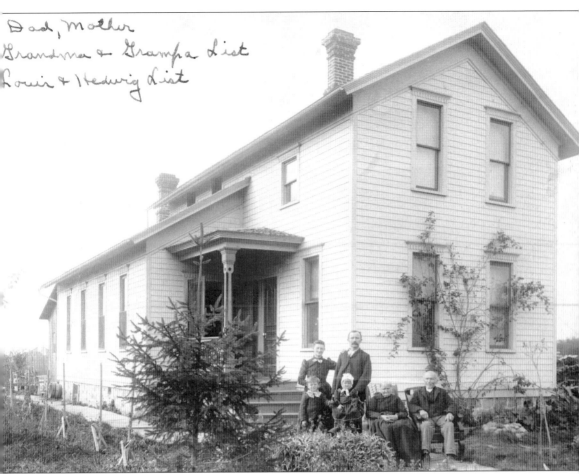

The List house is a typical early-1900s frame farmhouse. The chimney to the rear connected to the cooking area or summer kitchen, while the other served the central stove. Multiple generations, including grandparents, commonly lived together in one house. George and Margaretha List (seated) were among Frankenmuth's early settlers. Margaretha had been a house servant for Pastor Wilhelm Loehe in Neuendettelsau and later served as midwife in the pioneer community.

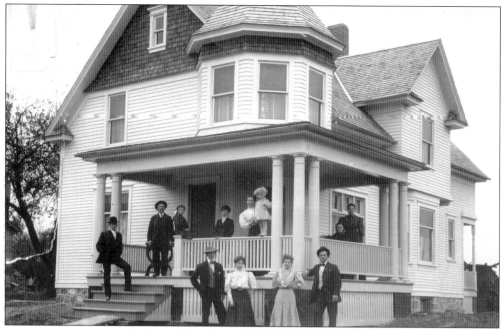

During its formative years, the vast majority of the community's population lived on their farms. But as the various craft and merchant establishments evolved, the proprietors naturally built residences close to those businesses. Once the sawmill began processing the plentiful timber, these homes reflected the growing prosperity of the community.

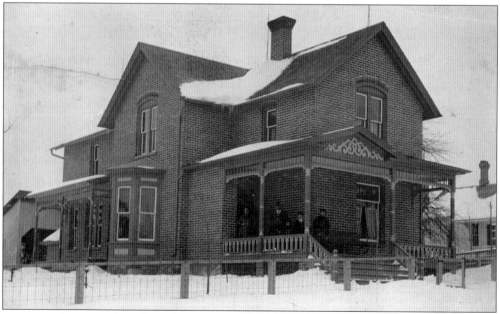

The natural progress from log cabins to frame houses culminated in beautiful brick structures like this, the Ranke family residence. Note the decorative detailing on the porches and the protruding bay window. Note also the roof peak lightning rods. The eaves troughs connected to a basement cistern, as the soft rainwater was much better suited for laundry than the more mineral-laden well water.

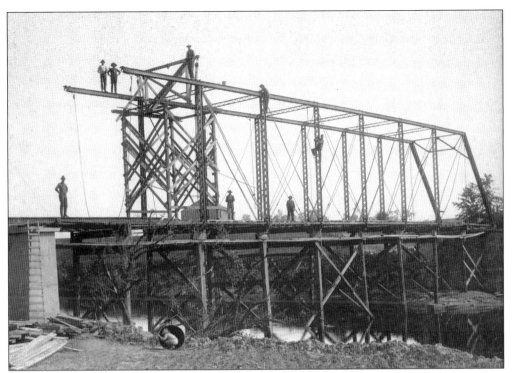

There were eventually three crossing points over the Cass River in Frankenmuth Township. The second (on Dehmel Road), popularly known as the "Black Bridge," was completed in 1907. It was eventually replaced with a modern concrete bridge in 1984, but the original structure has been preserved for historic purposes.

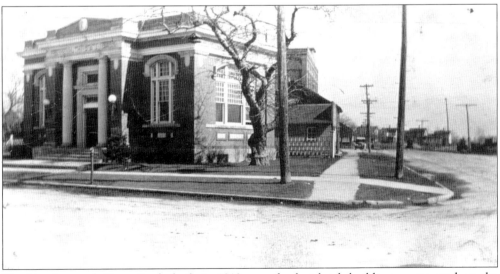

The Frankenmuth State Bank, built in 1910, was the last brick building constructed on the corner of Main and Tuscola Streets. It was almost directly across Main Street from the competing American State Bank, which closed during the Great Depression. The center building was the veterinarian offices of Drs. Mervin P. Hunt and Otto J. Conzelmann, with Star of the West's mill behind that.

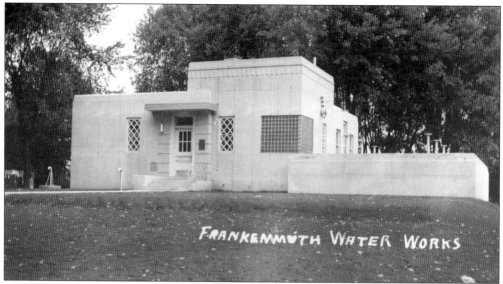

The earliest source of drinking water was the muddy and tepid Cass River, which was soon replaced with hand-dug shallow wells. A Depression-era Works Progress Administration project laid the first water mains along Main Street. At that time, a community well was dug into the low banks along the river, and a waterworks was constructed to filter and treat the village water supply.

Whether or not beer was one of the essential German food groups, it was undeniably the local beverage of choice. Nothing else could so ably satisfy the thirst generated by a day's labor in the fields. Moreover, it was a social lubricant for the many clubs and celebrations that distinguished the community. The first Frankenmuth brewery was established in 1857 by John Falliers near the top of the Main Street hill. In 1862, the Cass River Brewery was established on adjoining property and later acquired by the Geyer family, who operated it as a family enterprise for nearly a century. To the south of the river, stockholders organized the Frankenmuth Brewing Company in 1899. This operation was commonly known as the Gold Medal Brewery after its most popular product, Gold Medal Beer. Frankenmuth Brewing Company was sold to International Breweries in 1955. At the time of this picture, the brewery had the capacity to produce 500,000 barrels annually.

Seven

TRANSPORTATION

At the time of its founding, the only land-based access to Frankenmuth was a meandering trail along the Cass River between the miniscule settlements of Bridgeport and Tuscola. Of course, the river itself provided transport downstream to its juncture with the Saginaw River and the slightly larger frontier villages of East Saginaw and Saginaw City. But for most of the year, the Cass River accommodated only canoes or shallow-draft barges.

The first road was built to connect with the second Franconian colony, Frankentrost, established in 1847. Other than that, the Native American forest trails were absolutely sufficient. In fact, the relative isolation was considered a benefit, as it allowed the immigrants to maintain and practice their culture largely free of outside intrusions.

Eventually more passable roads, first plank and later gravel, provided a smoother ride for horse-drawn vehicles. But still, the ideal of self-sufficient isolation remained powerful. As the railroads exerted their unifying influence throughout the area, the Frankenmuth town fathers declined to be included, and the line was laid some five miles north of the village.

Yet an exception was made in the case of the interurban, which had established an electric-powered tram system between the cities of Saginaw and Flint. This north–south route passed six miles to the west of Frankenmuth. A request was made and granted for a spur line to cover that distance, providing access not only for passengers but also for freight.

It is perhaps ironic that the early efforts to remain disconnected actually fostered the uniqueness that later proved attractive to visitors. With the coming of the automotive era and the highways that accompanied it, the quaint village was suddenly only a few hours drive from major metropolitan areas.

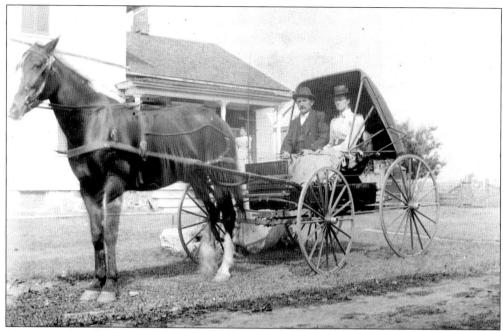

Much as with today's automobiles, a well-kept rig was a matter of pride as well as utility. In this 1899 photograph, the buggy top is in a rather unusual half-mast position. Possibly that was a protective measure for the occupants attired in their Sunday best. The horse is equally well currycombed for the occasion.

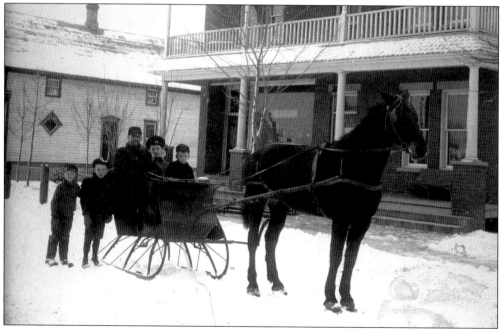

In the preautomotive era, clearing snow from the wintry streets was not an issue. As the snow became hard packed, calks affixed to the horseshoes provided sufficient traction for the horses to draw the sleighs and cutters. This picture was taken in front of the Commercial House hotel near the bottom of the Main Street hill.

64

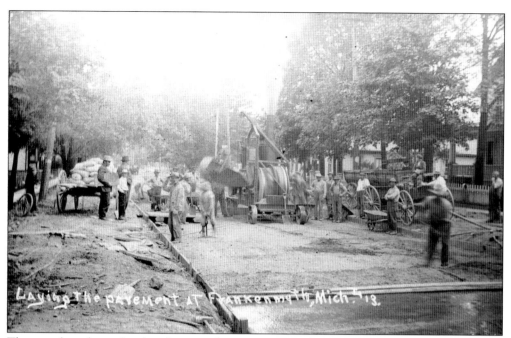

The gravel roads, surfaced with stones from a pit in nearby Tuscola, were a general nuisance, especially to automobiles. Frankenmuth's Main Street was paved in 1913, only shortly after the nation's first paved street in Detroit. The trees shown on each side of the street were later victims of road-widening projects.

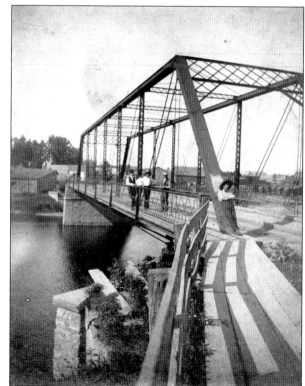

This picture of the Main Street bridge facing north was taken in the late afternoon, evidenced by the shadows cast by the fence onto the planks of the pedestrian walkway. The year it was taken is less certain, but the bridge was constructed in 1893. Note the large lumber piles in the Hubinger sawmill yard (right).

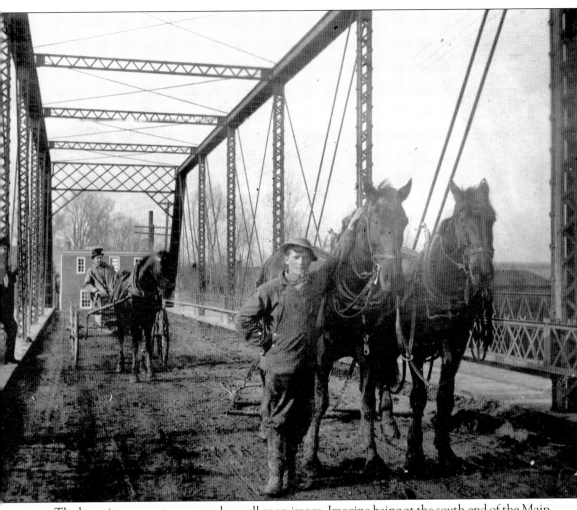

The best pictures capture a mood as well as an image. Imagine being at the south end of the Main Street bridge shortly after 1900. Approaching are a pedestrian, a wagon driver, and a man with a team. All would certainly stop for a brief chat. Most likely they would be cousins, to a greater or lesser degree. The conversation would be conducted in Fränkisch, the Germanic dialect brought by the first settlers more than a half century earlier and still the common language. The topics might include family and friends, agricultural conditions, church events, or new businesses being developed in the town. Just as the bridge joined both sides of the river, the communal bonds of that earlier village united its inhabitants into a cohesive entity.

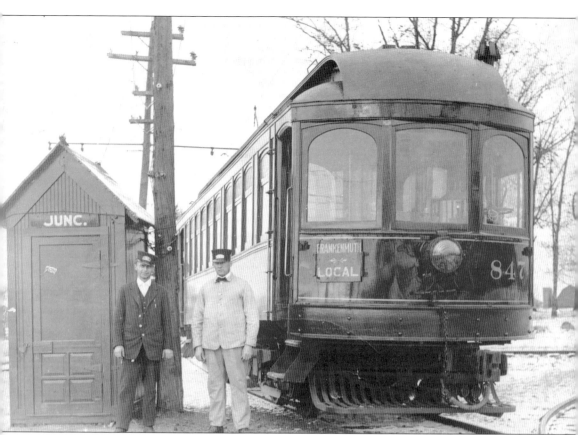

The main line of the interurban ran north and south between Saginaw and Flint. Approximately six miles west of Frankenmuth was the junction, depicted here, with the spur line that served the village. Generations after the demise of the interurban, the road that ran alongside it is still known as Junction Road.

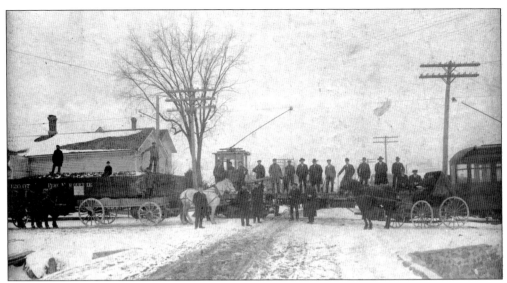

Along the six-mile spur of the interurban between the junction and the village were several stops to provide access to the tram. This picture shows one of these stops. The horse-drawn wagons provided transport to and from the pickup point.

The local interurban spur terminated in a loop around several blocks thereby reversing its direction. It entered town from the west along Genesee Street, shown at left. Note the backyard garden to the right of the wooden poles. These poles carried the electricity to power the tram along the tracks.

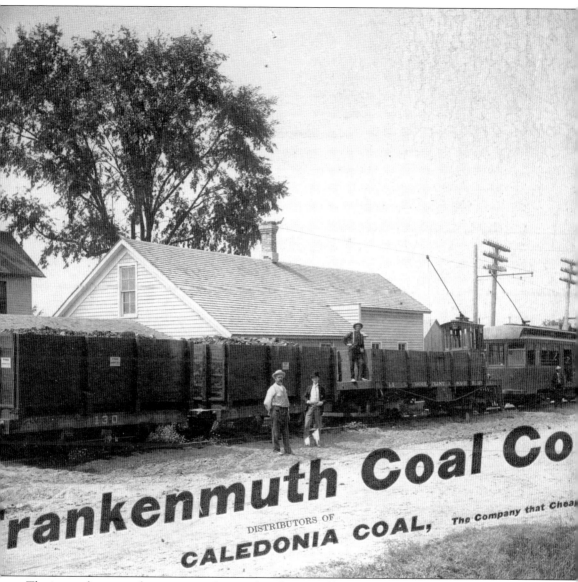

The interurban served as transport for merchandise as well as people in the era before cars and trucks became common. Coal was used to heat homes and commercial buildings, since woodlots were not available within the village. In this picture, the arms that connected the engines to the electric lines are clearly visible.

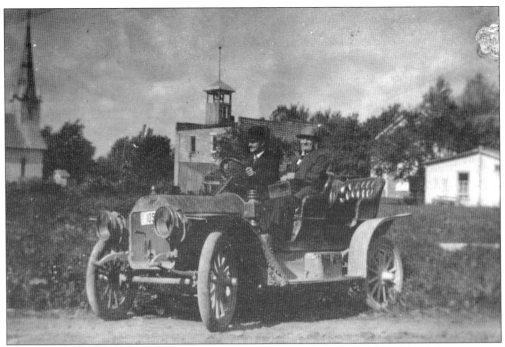

Some of the earliest automobiles provided much-needed transport for the medical practitioners. Here Dr. Clarence W. Stowe, the veterinarian, is driving, with physician Dr. Friedrich J. Hohn as passenger. They are headed south on the still-unpaved Main Street. Immediately behind them is the township hall, with the St. John's church partially visible at left.

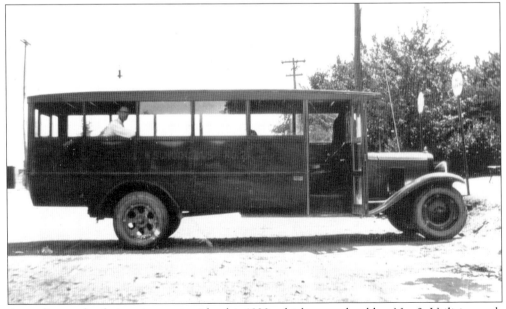

According to the designation on its side, this 1930 vehicle was school bus No. 2. Utilizing such buses meant more than mere convenience. Because it was possible to convey students from the outlying farms, the multiple one-room schoolhouses could be consolidated at a central site in the village, with teachers being responsible for single, rather than multiple, grades.

Eight

COMMERCE

To understand the development of commerce, the local desire for self-sufficiency must be considered. The processing of grain into flour and logs into lumber made the mills a logical starting point. German heritage also dictated that the beverage of choice should be brewed within convenient proximity.

Beyond these essentials, there were a myriad of products and services directly related to agriculture. Blacksmiths, harness makers, butchers, and wool processors were among the earliest craftsmen. Merchants of general goods and livestock soon followed. Many establishments purveyed a wide assortment of merchandise, tailoring their stocks to local demand. Advertising was limited to storefronts and windows.

By modern standards, there were an inordinate number of saloons sprinkled along Main Street. But the primary function of these establishments was social, providing a venue for card playing, conversation, and fellowship. Indeed, the beer steins were relegated to niches beneath the playing surface of the card tables.

Most of the saloons were situated within hotels, often with attached livery stables. In a small village well off the beaten track, demand for such accommodations would not seem to justify the number. But many of the visitors were traveling salesmen who met with the local merchants to promote products. With the primitive transportation of the time, such visits required overnight stays, and the improving prosperity of the area made such marketing worthwhile.

An integral requirement of the lodgers was sustenance. The fresh local produce in the simple recipes of meticulous farm-trained cooks resulted in memorable dining. The family-style chicken dinners, which later became the world-famed basis of a tourist industry, had origins in such humble hostel meals.

It is noteworthy that, for most of its history, the only products exported from the community were agriculture based. The work ethic of the residents' heritage, melded with the fertility of their farmlands, resulted in sufficient productivity to provide comfortable incomes for both farmers and merchants.

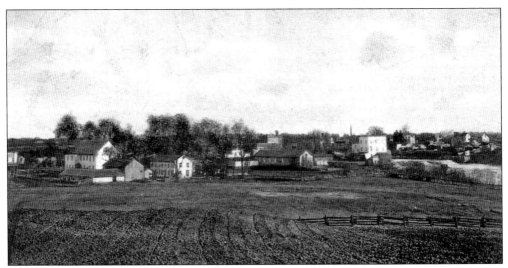

This beautiful panorama of Frankenmuth is from about 1905, 60 years after its founding. The view is looking east toward Main Street. The Hubinger mill is visible (far right) with the dam and river nearby. The smokestack served the steam-driven sawmill. The new Exchange Hotel (left) later became Zehnder's. Note that the farm fields of that era extended right up to the narrow strip that comprised the business district.

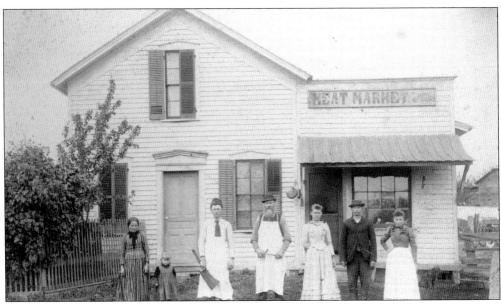

In the early days, the same building often housed both a residence and an adjoining shop. Christian Freudenstein's meat market was located on Tuscola Street. Typically the entire family was involved in a business, often including several generations, as seen here. Note the fenced side yard (left) and barnyard (right).

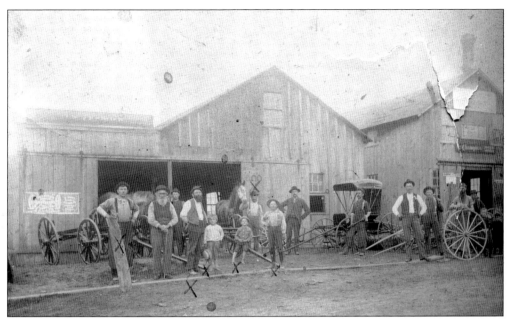

As more and more mechanical innovations became available for agriculture, it was natural for the local blacksmiths to begin merchandising such equipment. In this picture, the John M. Zehnder enterprise is advertising Champion binders and mowers. Many of the early blacksmith shops later evolved into farm equipment and even automotive dealerships.

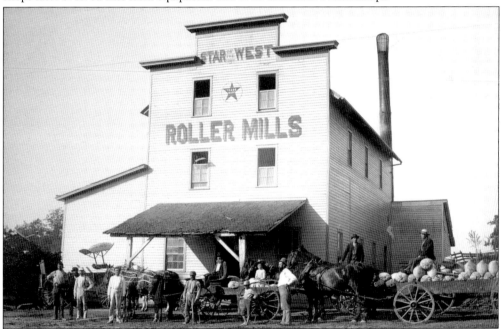

The Star of the West mills were located on Tuscola Street. This 1890s picture shows a wagon (right) loaded with the finished bagged flour. The smokestack vented the boilers that provided steam to power the rollers. The unusual name of this enterprise, which continues to this day, originated from a Civil War ship that received the first volleys of the war while attempting to resupply Fort Sumter.

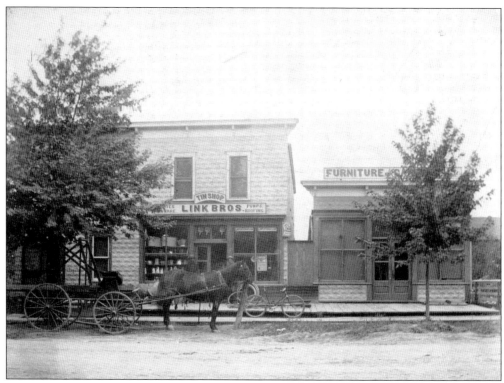

The Link Brothers Tin Shop provided an extensive assortment of housewares of the era, shown in the window, as well as producing roofing, ducts, troughs, and similar tinware. Next door (right) is the Fred Gugel Furniture and Grocery Store. Note the 1890s bicycle just in front of the horse and wagon.

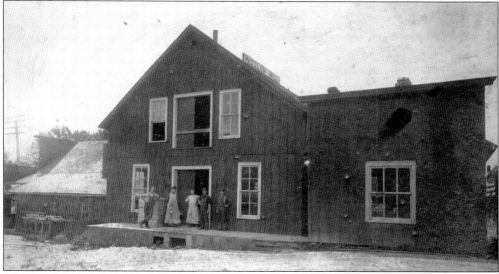

The Frankenmuth Woolen Mill was yet another local business founded to fill a practical need. While sheep were never extensively raised in the area, the cold winter climate demanded warm quilts, blankets, gloves, socks, hats, and other clothing. In addition to the finished products, the skilled housewives employed yarn and batting for their home-crafted masterpieces.

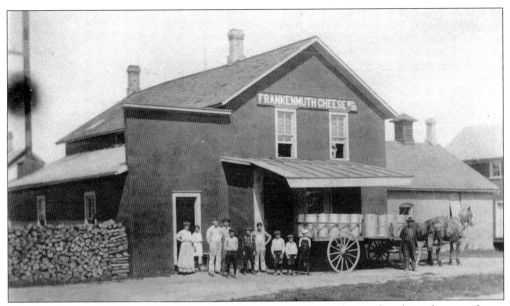

The Frankenmuth Cheese Manufacturing Company was one of several such in the area. In an era before mechanical refrigeration, cheese was a logical way of preserving the bountiful milk from numerous dairy herds. Note the large milk containers on the horse-drawn wagon, whose daily route covered many farms, and also the huge woodpile that provided the steam to power the processing.

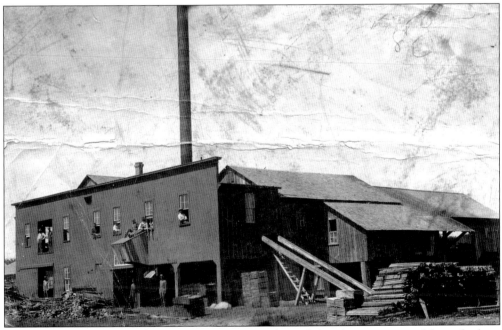

The Veitengruber Lumber Mill on Genesee Street depended on horsepower to deliver the logs. The unusable slab wood from the outside cuts provided the fuel to drive the saws. One specialized product of this enterprise was the round cheese boxes used in packing the output of the many nearby cheese factories.

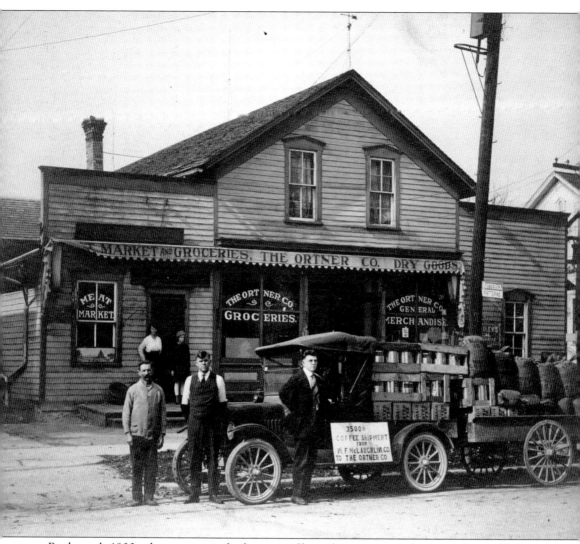

By the early 1900s, the community had grown sufficiently to accommodate several general stores. Typically each customer family maintained an account. Purchases were charged, and deliveries, such as vegetables, fruits, butter, and eggs, were credited. Much of the meat and produce was grown and consumed on the farms, but there were always additional items that needed to be store bought. Depicted here is a coffee shipment being delivered to the Ortner Company store on Main Street. This photograph indicates that the road was not yet paved. In addition to groceries, the stores carried dry goods and general merchandise. Note the power line and transformer. The Frankenmuth Light and Power cooperative was organized in 1910, which places the date of this picture at that time. Refrigeration for perishables, such as fresh meats and dairy products, was provided by large blocks of ice. That ice was harvested from the Cass River during the wintertime and preserved in an icehouse, insulated between layers of sawdust.

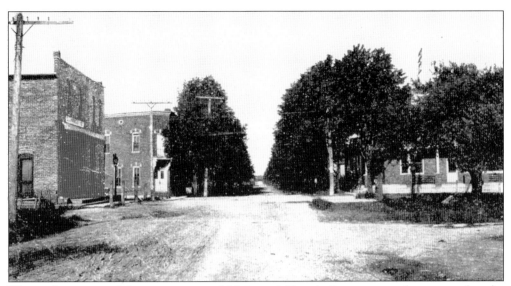

This early picture of the intersection of Main and Tuscola Streets was taken soon after the arrival of telephone lines in 1904. To the left is Hubinger's General Store, later known as Aunt Hattie's. The entry to Geyer's Saloon faced the corner for easy access from either side. Its parking lot, to the rear, was reserved on Sunday mornings for St. John's church members. The List Hotel is to the right.

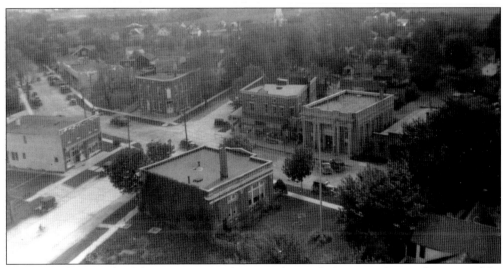

This 1938 photograph of the intersection of Main and Tuscola Streets indicates that most of the business structures were sturdy brick. Clockwise from left to right are Hubinger's General Store, Geyer's Saloon, the Ortner Company store, American State Bank, and the Frankenmuth State Bank. In the background is the steeple of St. John's Evangelical Lutheran Church.

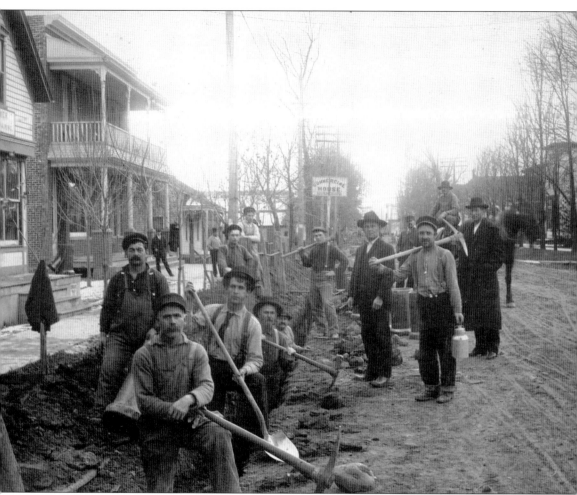

The Frankenmuth community has always kept pace with innovations in infrastructure. Here the first sanitary sewer is being constructed along Main Street in 1910. Even though it terminated in untreated discharges into the Cass River, it was generally considered to be an improvement over outhouses. The gentleman on horseback (rear) is marshal Martin Eischer, the supervisor of public works and also the local law enforcement officer.

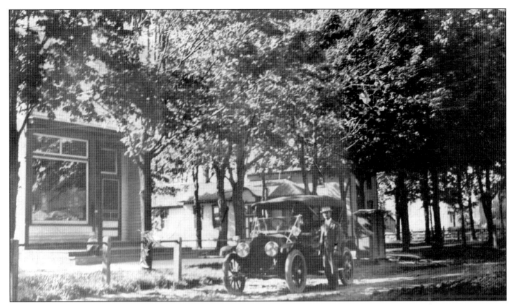

Some of the earliest owners of automobiles were the medical practitioners in the era when house calls were the norm. Here Dr. Friedrich J. Hohn poses with his vehicle on the yet-to-be-paved Main Street, and the country roads proved an even more formidable challenge. The hitching rail (foreground) saw many more years of use.

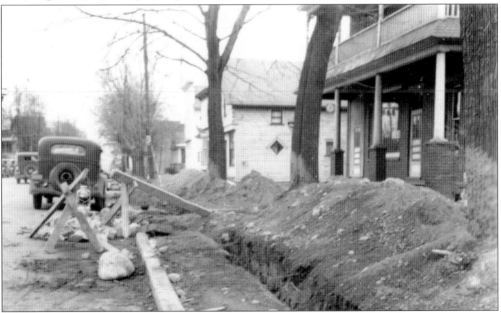

The make-work projects of Pres. Franklin D. Roosevelt's Works Progress Administration produced many worthwhile results. Here the first water mains are laid along the east side of Main Street just in front of the Commercial House hotel. Prior to that, every house and business relied on wells for its water supply, with the ever-present danger of contamination. As part of the project, a community well was dug along the banks of the Cass River, and a water treatment plant was constructed to filter and treat the water. The system served until the mid-1950s when a supply of Lake Huron water became available via a line from Saginaw.

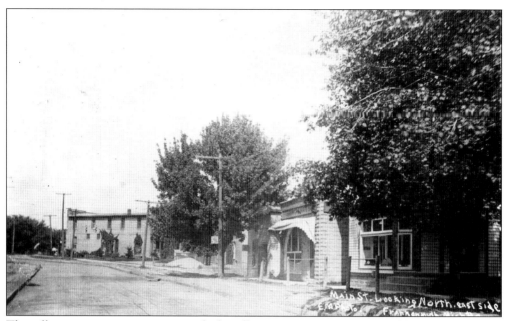

The village was, in many ways, typical of small-town America prior to World War I. A primary distinguishing feature was a commitment to German heritage in terms of self-sufficiency. This picture shows Main Street looking north at the top of the hill. The large building (left) is Hubinger's General Store. Also visible are the canopied Jenney Bank building and Bernthal Jewelers.

Granite cast stone was a popular building product in the 1920s. It was showcased in the facade of the Main Street factory that produced it. The distinctive blocks, with an elongated diamond pattern, can still be seen on buildings of that era. The factory was demolished in 1970 to make way for a shopping mall.

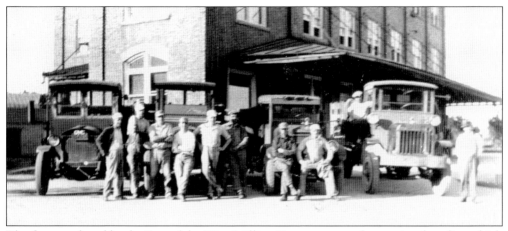

The flour produced by the Star of the West Milling Company was of exceptional quality, which resulted in demand far beyond the local area. A natural consequence was that the company established its own fleet of delivery trucks. Depicted here are some of those early vehicles along with their drivers.

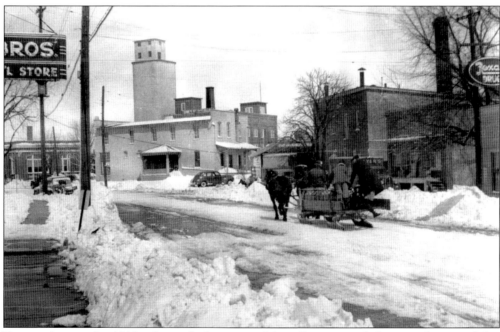

Even as late as the 1940s, the packed snow on Main Street provided reason for use of this horse-drawn sledge, transporting cans of milk to the cheese factory in the next block. Also visible are, from left to right, the Frankenmuth State Bank, Hubinger's General Store, and the Geyer Brewery complex, with the Star of the West silo towering in the background.

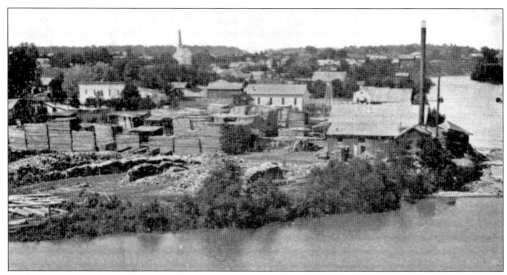

In this picture, a relatively small number of logs remain in the river. From the time of the spring floods throughout the dryer seasons, the inventory in the river was constantly drawn down. The lumber stacks shown in the yard are in the process of air-drying. Lacking a railroad, any lumber used outside the village required horse-drawn transport.

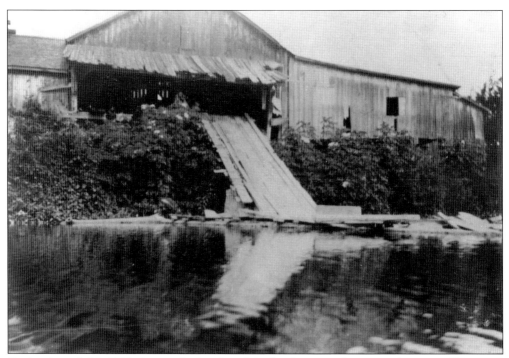

By the time of this 1927 picture, the heyday of the lumbering industry was long past. The ramp elevated the logs from the river up to the awaiting steam-powered saws. All that remains today of that industry of yesteryear is one of the concrete ramp footings, which can be seen just upstream from the west end of the *Holzbrücke*, or wooden covered bridge.

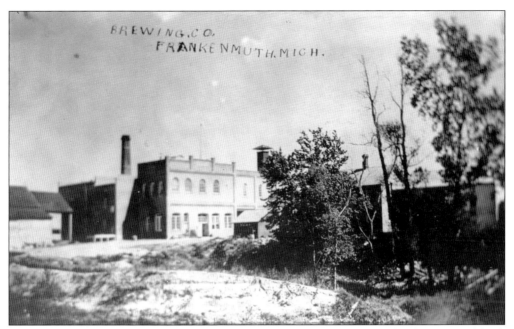

Brewing was one of the earliest Frankenmuth businesses. The beverage has been traced back as far as the ancient Egyptians but was perfected among the Germanic peoples. Over the years, several local breweries have come and gone and transferred ownership. The Frankenmuth Brewing Company, shown here around 1910, eventually achieved national status.

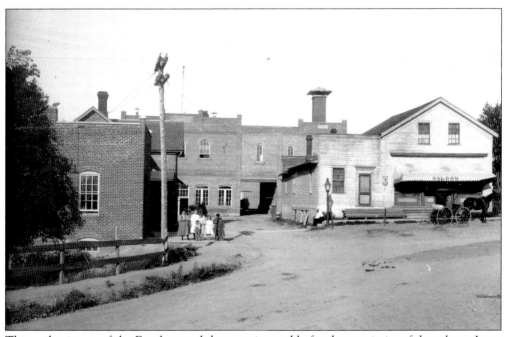

This early picture of the Frankenmuth brewery is notable for the proximity of the saloon. Long before the concept of "born on" dates, the superiority of freshly brewed beer was appreciated in Frankenmuth. The vast majority of the locally produced beverage was consumed well in advance of any potential decline in flavor or freshness. (Courtesy of Wallace Weiss.)

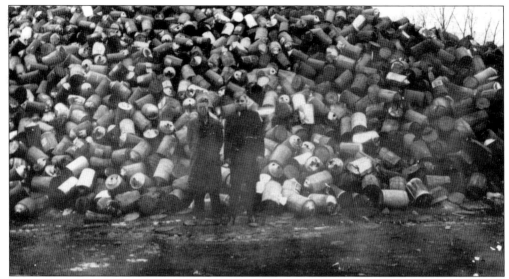

Prohibition was a well-intentioned social experiment not much welcomed by most Frankenmuth residents. Partially as a matter of self-preservation but mostly to accommodate local demand, the breweries switched to production of malt extract, an essential ingredient for home-brewed beer. When the noble experiment was finally repealed in 1933, the breweries joyously dumped the cans of extract, pictured here, and resumed their proper intended function. (Courtesy of Wallace Weiss.)

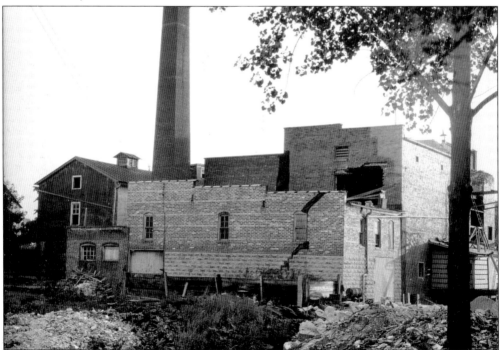

After the repeal of Prohibition, there was a substantial amount of government red tape to be navigated before brewing could be recommenced. This 1933 picture of the Frankenmuth Brewing Company was used to apply for a new brewing license. On the back it bears an embossed seal of approval from the U.S. Department of the Treasury. (Courtesy of Wallace Weiss.)

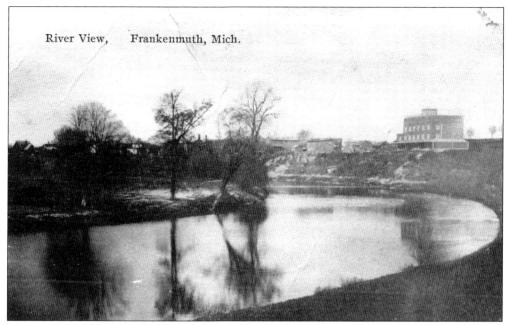

River View, Frankenmuth, Mich.

This is a beautiful view of the Cass River at the bend just downstream from Hubinger's Grove and slightly upstream from the village. The large building to the right is the Star of the West mill that operated on steam rather than waterpower. In the center is the Geyer Brewery complex. Both of the industries were essential to Frankenmuth's prosperity.

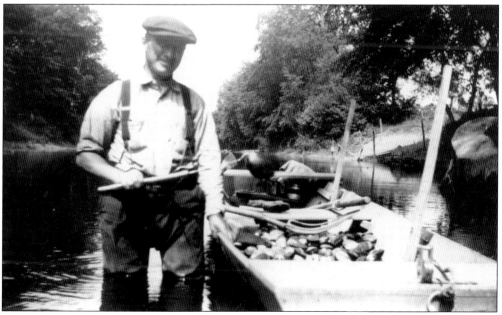

Beyond being a source of spring floods and summer recreation, there were also commercial aspects to the Cass River. In the early years, abundant fish were salted into barrels and shipped to metropolitan areas. Ice was harvested in winter and gravel in summer, and the abundant clams, shown here, furnished the raw material for mother-of-pearl buttons.

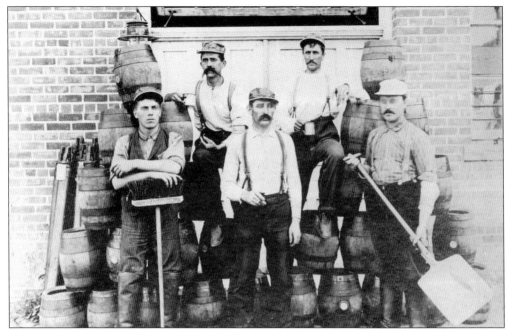

These early-20th-century brewery workers appear to be taking their jobs seriously. Perhaps the ones in the rear holding the cups are official testers. The cigar-holding man (center) is pictured long before the no-smoking-in-the-workplace era. The barrels behind them are known as "pony kegs," and several might be needed for a typical wedding celebration or a picnic on a hot day.

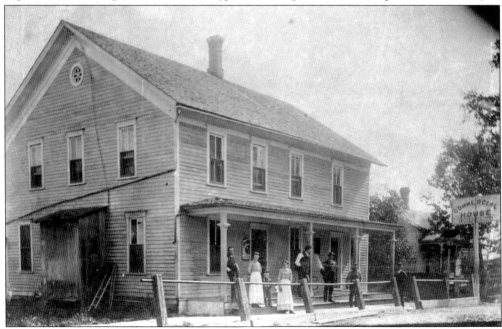

Around 1900, Lorenz Kern's Commercial House was ensconced in a typical frame clapboard building. In 1905, this building was moved back away from the road and replaced with a larger brick structure. Note the hitching rails (foreground), the parking spaces for the transportation of that era.

The new Exchange Hotel was built in 1900. The original proprietor was Fred "Fritz" Goetzinger. After passing through several hands, the property was acquired in 1928 by William and Emilie Zehnder and eventually became Zehnder's restaurant, a keystone of today's tourist industry. Portions of this original building remain incorporated in the present restaurant.

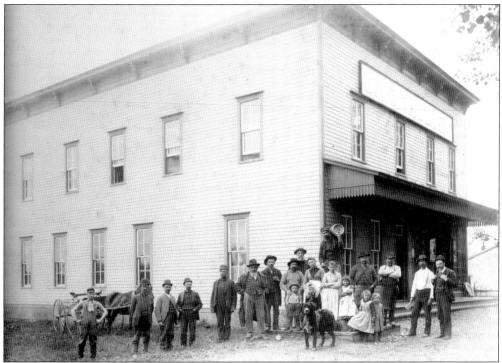

Across the street from the Exchange Hotel was the Union House, another of the many local *Gasthäuser*, or hotels, of the era. Aside from a few local boarders, most of the patronage was from commercial travelers. With no railroad and miles separating Frankenmuth from the Saginaw-Flint Plank Road, there were few travelers just passing through. The Union House later became Fischer's Hotel and eventually the Bavarian Inn.

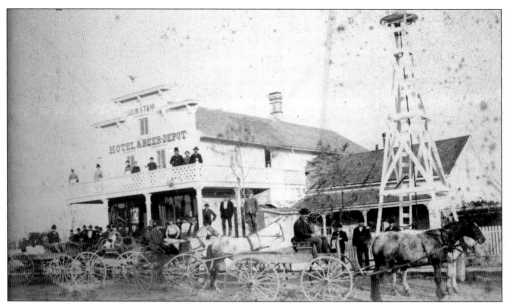

The John Stahl Hotel and Beer Depot, which featured its own basement bowling alley, nearly adjoined the Geyer Brewery complex. A naive visitor once asked how, without a railroad station, the product of so many local breweries could be transported. The local residents just smiled in response. The breweries always had associated saloons, and the many *Gasthäuser* and retail customers absorbed the surplus.

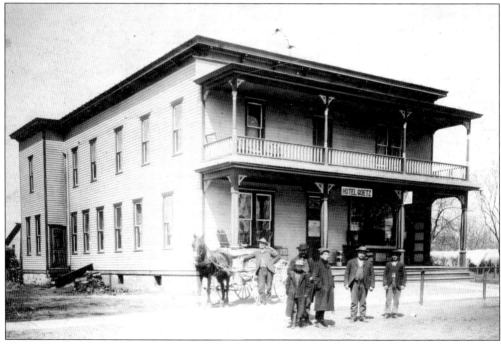

This 1910 picture of the Hotel Goetz shows the typical clapboard construction of hotels of that era. On the second floor, a lengthwise hallway extended back from the front porch, with rooms on either side for boarders and guests. On the lower floor (right, front) was the saloon, which remains in use today as Tiffany's, with much of its interior decor preserved.

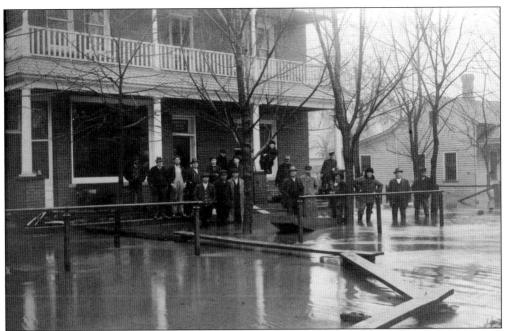

Most of the downhill businesses could expect an annual disruption when the Cass River surged over its banks onto the floodplain. Old-timers ranked the severity of each according to how high up the hill it progressed. In this photograph, a plank walkway is constructed across Main Street in front of the Commercial House hotel near the bottom of the hill.

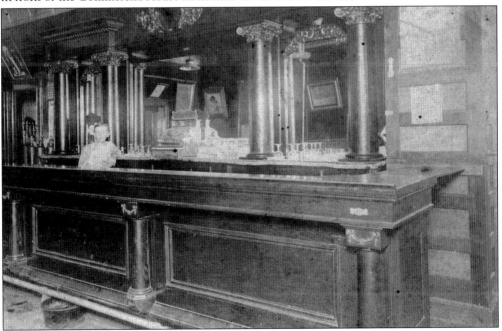

The saloons in the hotels were accorded elegance in keeping with their function. Beyond the traveling salesmen and boarders, there was a group of local regulars, almost like social clubs. The ornate bars often featured hand-carved walnut details and solid brass foot rails. Note the commodious spittoon conveniently located just below the rails.

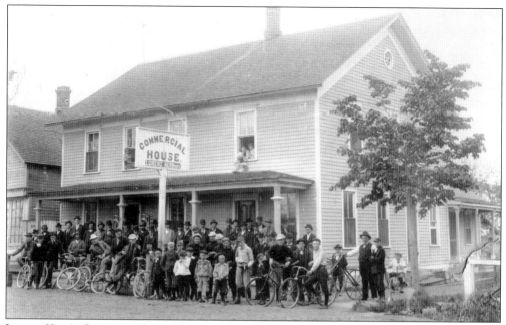

Lorenz Kern's Commercial House furnished accommodations for commercial travelers. Over the years, the structure underwent numerous alterations. After serving as a hotel, it was divided, with one half remaining a saloon, while the other housed the offices of the local newspaper. Still later it became the home of the Frankenmuth Historical Association. Eva Kern, wife of the proprietor, is credited with originating and serving the family-style chicken dinner.

An early version of the rental car was the livery stable. For many of the hotel guests, it was as indispensable as the taproom. Pictured is the livery stable just behind the Commercial House hotel. Note the two rows of holes near the top of the structure to provide access to the pigeon nests kept inside. Quite likely, squab was on the hotel menu, when available.

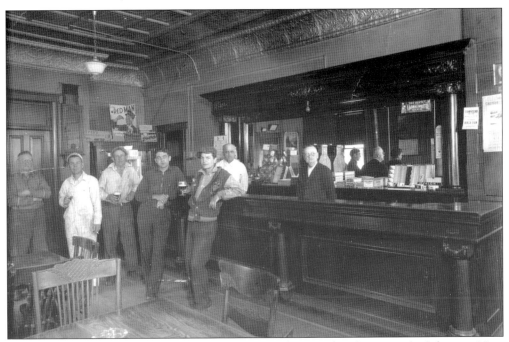

This photograph of the taproom in the Commercial House hotel is typical of the era. Note the highly decorative pressed-tin ceiling. The well-scoured tables were oak, with surprisingly comfortable pressed-back oak chairs. Tobacco products were much in evidence in those less enlightened times, with no smoking reserved for the ladies' parlor.

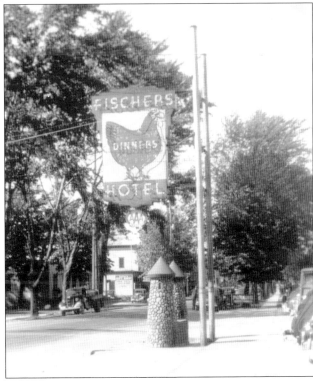

Fischer's Hotel was the intermediary between the Union House and the Bavarian Inn, all at the same location. In this 1920s photograph, the world-famous chicken dinners are already being promoted, with AAA endorsement. Between the decorative stone pillars is a watering trough for horses, a remnant of the preautomotive era.

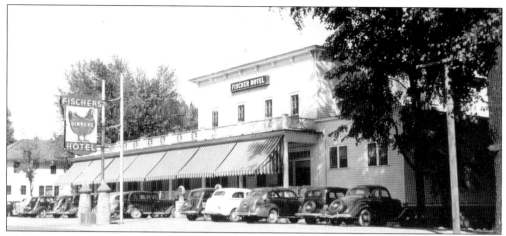

The filled parking spaces in front of Fischer's Hotel were a mere foretaste of the popularity yet to come. In this photograph, the distinctive neon sign is still flanked by the stone-pillared horse watering trough. The cars in the picture date it to the late 1930s, still well in advance of the post–World War II tourist boom.

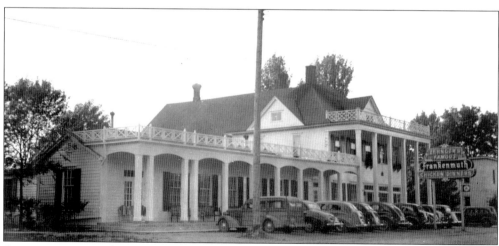

As tourism increased in the early 1940s, additional dining space was required to better serve the hungry visitors. The Zehnder hotel expanded by the addition of a south wing to what had originally been the Exchange Hotel. Frequent remodeling and innovations over subsequent years have continuously maintained the ambience of the dining experience.

Nine

SOCIAL LIFE
AND RECREATION

The earliest celebrations of fellowship were related to religious occasions. Marriages, baptisms, confirmations, wedding anniversaries, and even funerals were accompanied by bounteous feasts and free-flowing beer. Because of the many familial interrelationships, such festivities were usually community-wide events.

Another direct offshoot of the Lutheran faith was appreciation of and participation in various choirs, bands, and other musical exercises. The first congregationally called teacher at St. Lorenz was Simon Riedel, whose title, cantor, was invariably fixed to his name. He is credited with bringing the first piano to Frankenmuth and over many decades of service instructed and directed many musical groups.

Every farm, of necessity, maintained a woodlot to provide the life-sustaining warmth for the frigid Michigan winters. But those forest remnants had the additional benefit of furnishing readily accessible picnic grounds. The St. Lorenz Churchgrove, now partially occupied by the school, remains the site of many festivals and family reunions.

Perhaps the most widely utilized woodlot was Hubinger's Grove, located on the north bank of the Cass River, just east of the village. Over the years, many permanent concession buildings were constructed, ball fields laid out, horseshoe pits framed, and Sunday afternoon boat races conducted. For a century, it was the place to be in the summertime with entertainments for all generations.

Hunting and fishing were sports that originated as practical methods of supplementing food or controlling predators. The river also furnished a venue for swimming in the summer and ice-skating in the winter. Organized sports were frequently sponsored by local business establishments as a form of advertising or simply for generating goodwill among the many fans. Frankenmuth has a long tradition of excellence in a wide variety of sporting competitions.

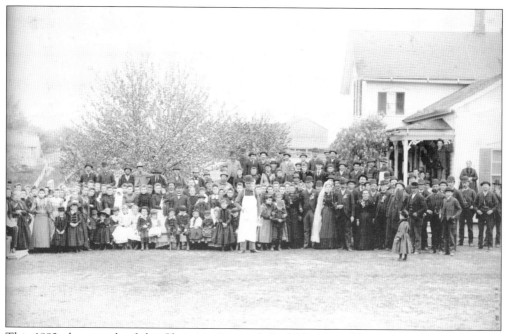

This 1892 photograph of the Christine Rummel–Paul Hauck wedding reception still features the bride in a black gown and the *Bierschenker* (beer server) prominently at attention. The little girl in the foreground seems determined to share the best view of the assemblage. Note how the children were typically dressed as miniature adults.

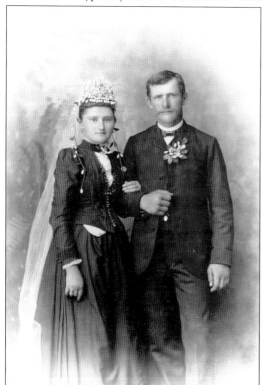

This 1895 wedding photograph of Elisabeth Gugel and Martin Weiss illustrates some of the Franconian customs that were maintained, even a half century after the immigrants arrived. The black wedding dress is the most obvious but also the wax-and-fiber construction of the groom's boutonniere and the bride's wedding crown that later might be framed for display in the family parlor.

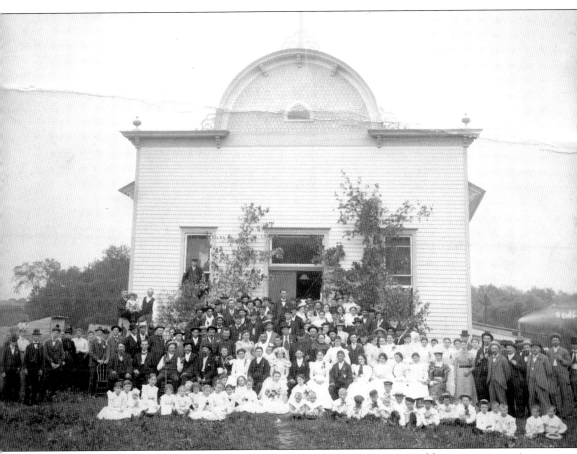

This 1898 photograph depicts the Emma Auernhammer–Max Rau wedding reception. As can be seen, the assemblage would have overwhelmed the house of the bride's parents, where such events were traditionally held. However, just a few years earlier, Theodore Fischer had erected Fischer Hall. Located behind his Union House (today's Bavarian Inn), it hosted local and traveling entertainment, medicine shows, and social clubs. As the only local facility of its type, it also served for weddings, graduations, and even funeral receptions. It was a movie theater, a roller-skating rink, and the site of the infamous Flint party during Prohibition. With the passage of time, it fell into disuse, serving only as a warehouse and storage space. In 1986, the William "Tiny" Zehnder Jr. family, proprietors of the Bavarian Inn, donated the hall as well as a piece of property adjoining the museum to the Frankenmuth Historical Association. Moved and refurbished, Fischer Hall today serves many of its original functions and remains a reminder of bygone festivities.

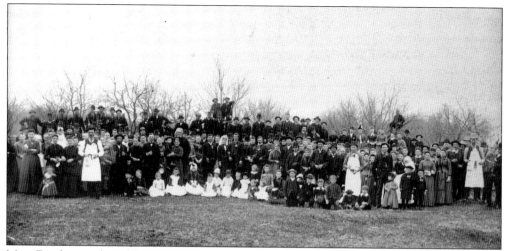

Most Frankenmuth wedding receptions were near community-wide events because of the many interfamily relationships. The 1899 reception for the Adam Lotter–Barbara Gugel marriage was typical. This was a three-*Bierschenker* celebration, with the bride still being attired in the traditional black. The many children arranged in the front are indicative of the typically large farm families common at that time.

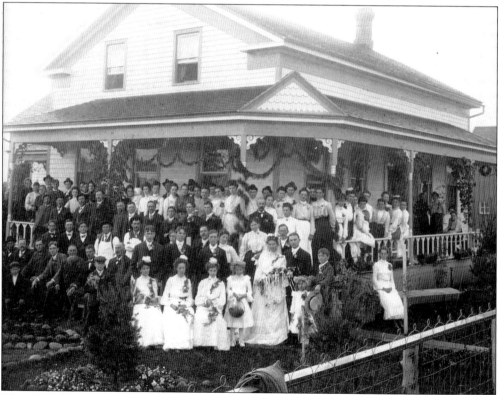

This 1903 photograph is of the Lily Voss–Arthur Hubinger wedding reception. As the bride was a daughter of Pastor Heinrich Voss, the building in the background was also a parsonage of that era. Note the decorative green garlands festooning the porch and the ornate fence surrounding the yard. One of the two flower girls is still carrying her basket.

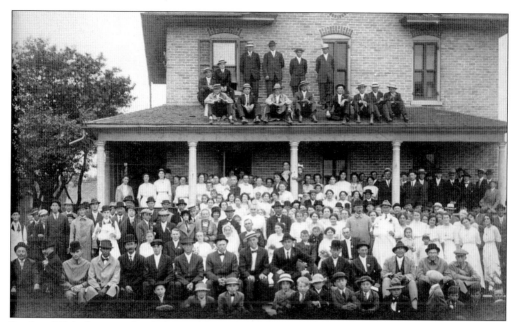

In this 1914 photograph of the Lydia Bender–William Bickel wedding reception, the solidly constructed brick farmhouse provides the background. Such farmhouses were typical of the era, and many continue in use today. The strict square lines of the structure are relieved by the decorative brick arches over the windows and the circular window in the attic. Even the porch roof was substantial enough to support several guests.

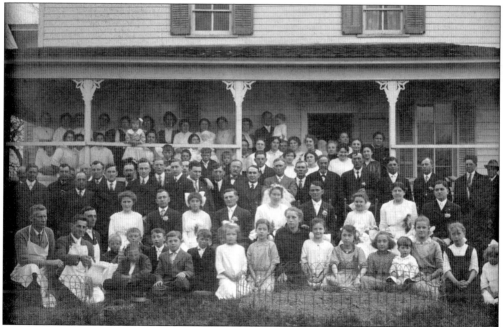

Wedding receptions were typically held at the home of the bride's parents. Note the decorative detail on the porch in this 1916 picture of the Elsie Dodenhoff–Martin Hubinger reception. Prominent in most such pictures are the apron-clad *Bierschenkers*, individuals who were responsible for keeping the guests' beer glasses filled.

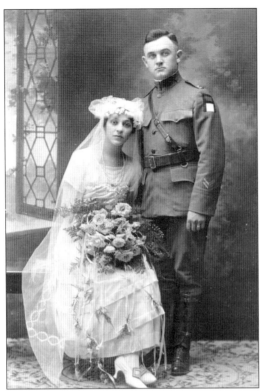

There was tremendous relief at the ending of World War I in 1918, yet many felt pride in having served. In this 1919 wedding photograph of Selma Veitengruber and Otto J. Conzelmann, he wears the uniform of the U.S. Army Veterinary Corps. Because of the extensive use of horses in that conflict, the services of men in his profession were especially valued.

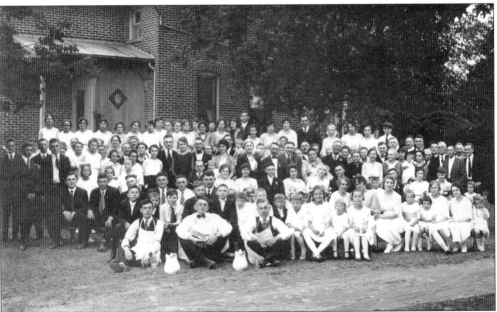

This 1920 photograph of the Florence Wenderlein–Erwin Geyer wedding reception is typical of the many celebrated following the conclusion of World War I. Note that most of the men have dark suits, while the ladies wear light dresses. Although Prohibition was in effect, the *Bierschenkers* are still prominent. It was perfectly legal to brew beer at home, using locally produced malt extract, and then to share it with guests. (Courtesy of Wallace Weiss.)

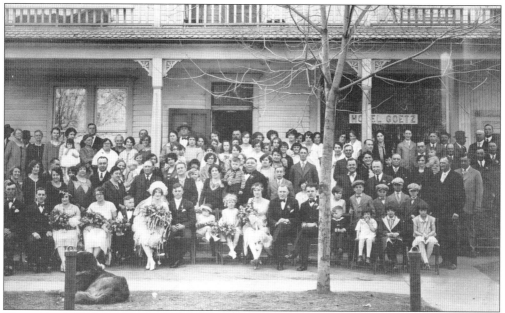

This 1928 photograph is of the Anita Zucker–Arthur Rauh wedding reception on the porch of the Hotel Goetz. By this time, flower girls and ring bearers were featured participants. The Hotel Goetz had been recently purchased by Henry Fischer, yet another of the community's genial hosts. His legendary, monstrous St. Bernard is seen near the hitching post (foreground). The animal was reputed to sit wherever he wanted to sit.

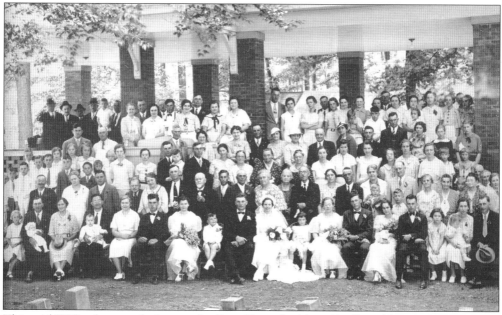

This mid-1930s photograph depicts the Erna Keinath–Alvin Knoll wedding reception in the Churchgrove. The brick structure is the bandstand, and the blocks in the foreground could hold planks that formed seating. Today much of the original grove land is occupied by the St. Lorenz school and soccer fields. But the bandstand, some surrounding buildings, and several ancient trees still provide an oasis for summer activities, including weekly church services.

The *Tannenbaum*, or Christmas tree, is a much-loved symbol of the season. This photograph from about 1900 was taken in the Link family parlor. In that pre-electricity era, the tree was illuminated by small candles that required constant vigilance when in use. Note also the ornate platform rocker with its intricate suspension system.

Among many childhood traditions was the *Osterhase*, or Easter rabbit. Children repeated a poem requesting the bunny to "hop over the meadow and bring a sack full of eggs to my nest." In the early years, candy substitutes were not yet popular. The eagerly sought nests typically contained beautifully dyed hard-boiled eggs.

This outdoor children's photograph from the early 1900s is clearly not a candid shot. The girls with their teddy bear, doll, and buggy are carefully posed on a backyard platform swing. Beyond the more common studio photographs, the local photographer occasionally transported his bulky equipment to the customer's home for the photo shoot.

Young Henry Fischer appears equipped for almost any contingency. The earliest toys were handmade from readily available materials. But as prosperity increased, store-bought toys became more prevalent. Fischer's outfit was purchased by his father on a business trip to Cuba relating to the cigar business. Military toys and games were not then considered potentially hazardous to developing psyches.

Only a few Main Street residences have survived, and most of them have been transformed for commercial use. But there was a time when they were part of a vibrant neighborhood with porches that welcomed friends rather than customers. This 1931 photograph is of the Walter Nuechterlein home at 636 South Main Street near the bottom of the hill.

The Fourth of July Kinderfest ranked right up with Christmas as the most enjoyed childhood experience. The festival always began with a patriotic parade to the Churchgrove site. In the early years, the parade began at the church, but by this 1940 photograph, the St. Lorenz schools were consolidated on Main Street, and the parade originated there. Note the band leading the parade and the many flags and patriotically decorated tricycles.

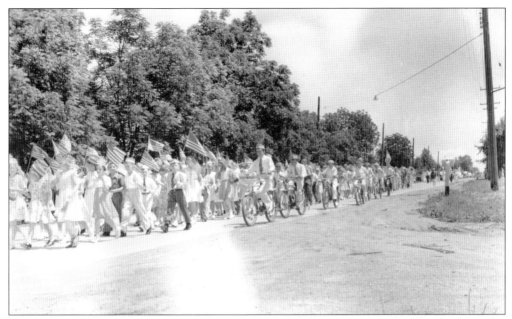

The highlight of every child's summer was the Kinderfest, held each Fourth of July in the St. Lorenz Churchgrove. There were all sorts of foods and games followed by evening fireworks. A local band played patriotic songs in the bandstand, and the adults enjoyed horseshoes, bowling, tugs-of-war, or simply visiting with friends. Here the Kinderfest parade makes its way to the Churchgrove.

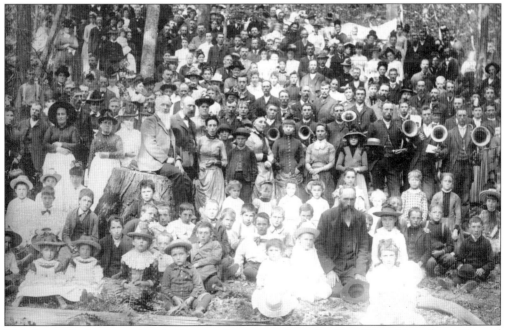

This is a typical community picnic scene in a grove along the Cass River. Note the uniformed band members. The adults and even the children appear dressed in their Sunday best. The Goodrich brothers, legendary photographers from the east side of Saginaw, came out to the country to memorialize this gathering from about 1900.

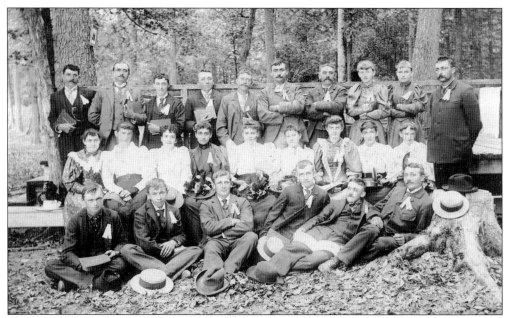

This is the Western District Singverein choral group. Each of the St. Lorenz schools had its own distinct geographical boundaries. This 1890 photograph was taken in the St. Lorenz Churchgrove. While the various local groups often entertained audiences there and elsewhere, the prime motivation was their own enjoyment and sociability.

This 1910 picnic of family and friends in Hubinger's Grove features plentiful food and beverages. Note the wheelbarrow (right) used to transport the feast down the rather steep bank to the riverside picnic area. One of the ladies is wearing a men's straw skimmer hat, while the man in front of her is wearing a women's sunbonnet backward. It is doubtful that the keg (foreground) contained lemonade.

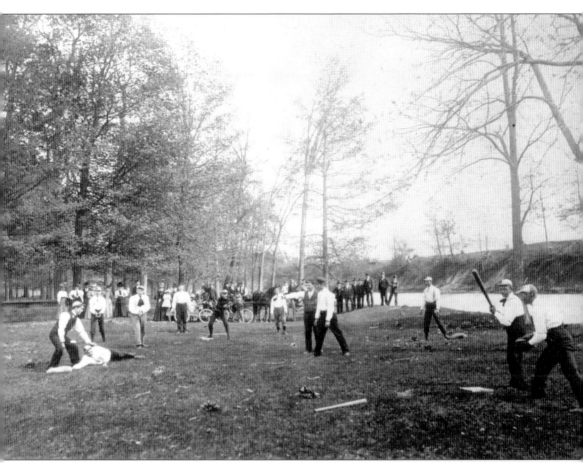

Much of the community's social life occurred at facilities such as Fischer Hall, the Churchgrove, and Hubinger's Grove. While every family had its own woodlot that could be used for small picnics, the larger groves could accommodate community-wide events. Hubinger's Grove was located just east of the village at a beautiful bend of the Cass River. Owned by the same family that developed Frankenmuth's first mills, it became a favorite gathering spot. Over the years, permanent structures were built as concession stands, selling beer, pop, candy, ice cream, and other snacks. There was a rifle range, horseshoe pits, and, as shown here, a baseball diamond. In the pictured game, the sliding runner appears safe, as signaled by one of the onlookers, probably the umpire. Note the considerable number of spectators, including the well-dressed ladies and boys with bicycles. Long before today's more organized and tourist-oriented festivals, the people of the village enjoyed the fellowship of their impromptu outdoor amusements.

Confirmation is an essential rite of passage for every member of the Lutheran faith, usually at the age of 13 or 14. At the time of this 1900 photograph of Anna Leidel, there were fewer memorable occasions than in the modern era. For a young lady, this was the most important event until her wedding

Backyard visiting with friends was a popular way to pass the time. Here two well-dressed young ladies share a platform glider. Another similar glider sits next to the porch. This type of lawn furniture was available by mail-order catalog but was more likely made locally from the plentiful wood.

These young ladies of the Reichle family are engaged in embroidery, quilting, and crocheting. Many of the items required for everyday use were handmade, with individual expressions of artistry adding beauty to the end product. Although a few were preserved, most were simply worn out as they served their purpose.

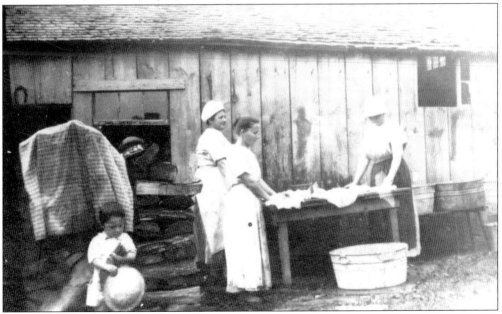

One aspect of the Franconian heritage is frugality, the abhorrence of anything being wasted. These ladies are engaged in making *Kuddelfleisch*, or pickled tripe. This delicacy is prepared from the stomach of ruminants and was much enjoyed. Many of the early recipes are still popular among both residents and visitors and are available in butcher shops that preserve the generations-old craftsmanship.

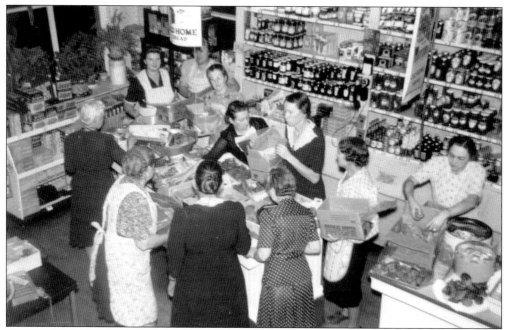

Despite family bonds to the old country, the patriotism to America was demonstrated in many ways during both world wars. Here a group of local ladies is preparing packages to be sent to the servicemen. The scene is inside Hedwig "Aunt Hattie" Hubinger's grocery store. Some of the African violets for which she was famed can be seen in the upper left window.

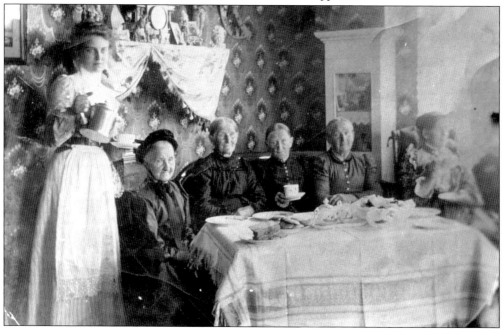

In this picture, Lily (Voss) Hubinger, is shown hosting a *Kaffeeklatsch*, an afternoon social gathering for ladies. Such semiformal ceremonies took place in the parlor, a room normally set aside from everyday activities and specifically reserved for entertaining. In that bygone era, simple conversation among friends was considered adequate entertainment.

This depiction from about 1900 is of a couple dressed in full Halloween costumes. They were apparently willing to share the treats collected in a cooperative sack. Parties and celebrations were an integral part of community life, where most of the entertainment was of the homegrown variety. Costume parties at the hotels were also well attended.

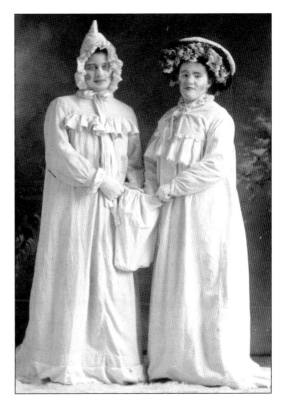

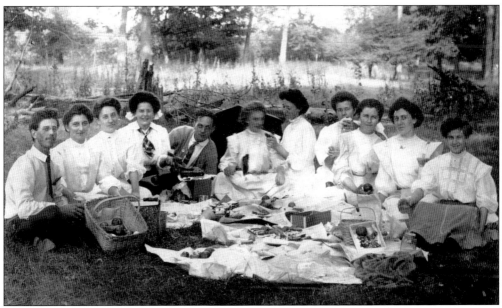

The ladies of the Minihaha Club are shown entertaining at a box-lunch social, the club name possibly relating to the Native American–made baskets depicted. Much of the entertainment at the time relied on sociability, although the young men shown here seem a bit outnumbered. Note the relatively formal attire for a picnic.

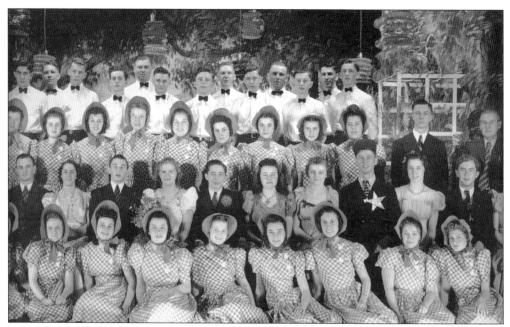

The Walther League was a young people's society sponsored by the Lutheran Church. Among the many approved activities were theatrical productions with ready-made audiences of friends and relatives. This picture shows the 1936 operetta *Sunbonnet Girl*, which was staged in the upper-floor auditorium of the recently completed St. Lorenz consolidated school.

While men typically had their musical and sports groups, Frankenmuth ladies also enjoyed their social get-togethers. The population was not inclined to mobility, so school age friendships were often maintained throughout life. Often the groups engaged in charitable projects or activities, such as the Du Well Club shown here in the mid-1940s. (Courtesy of Ellen Duff.)

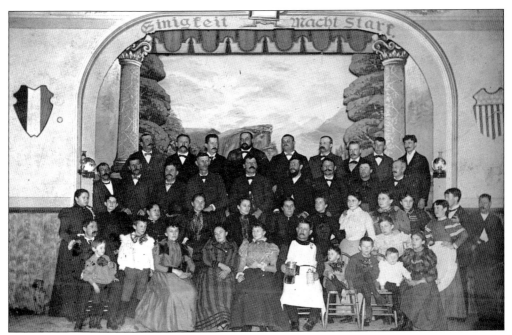

The Gray Fox Club was one of Frankenmuth's earliest social organizations. The men-only group nevertheless sponsored holiday family parties. This early-1900s photograph was taken at Fischer Hall. The left shield portrays the colors of the German flag, with the Stars and Stripes proudly displayed on the right. Above the arch is the motto *Einigkeit Macht Stark*, which translates as "strength through unity."

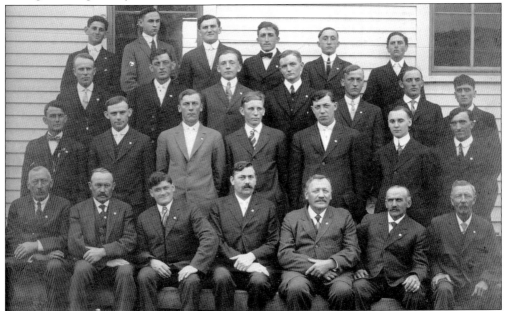

This picture of the Concordia Male Choir was taken just prior to World War I. The choir was organized in 1875 by St. Lorenz teacher "Cantor" Simon Riedel. The participants span the spectrum of age groups. Beyond the strictly choral function, the group served also as a social club. In addition to singing in the church, it also performed an annual concert of lay music.

Here is another gathering of the Concordia Male Choir. *Concordia* is a German Lutheran term denoting unity. Although well versed in church music, the group generally concluded its practices with more emphasis on fellowship. The practices were often held in an upstairs room in the township hall adjacent to the one-room jail, which was seldom in use.

These desperados are actually the Katzamuzik Club. After marriage ceremonies were solemnly concluded, the often boisterous celebrating began. The group pictured here displays a variety of noisemaking implements, including cowbells and shotguns. The fellow on the right holds a stick of dynamite then commonly available for stump removal. The newlywed couple would be "serenaded" until appropriate ransom, in the form of liquid refreshment, was provided.

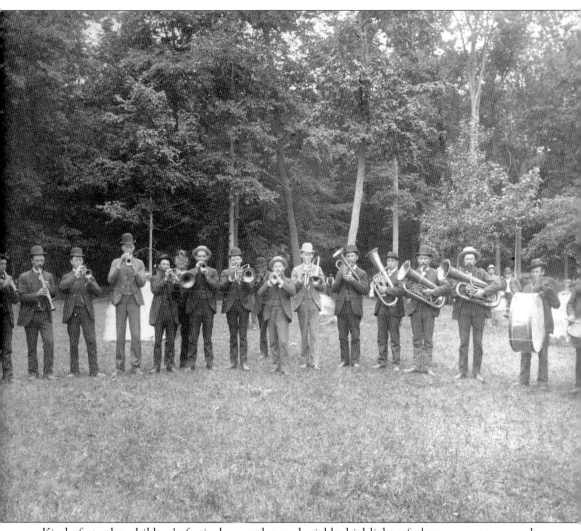

Kinderfest, the children's festival, was the undeniable highlight of the summer season. It combined the celebrations of the ending of the school year and the Fourth of July. While nominally for St. Lorenz children, it was actually enjoyed by the entire community. The parade was led by town marshal Martin Eischer on horseback followed by a band and then the children on their patriotically decorated bicycles and tricycles. Awaiting them at the Churchgrove was a fun-filled afternoon of games, Rupprecht's hot dogs, homemade lemonade, ice cream, candy, and other delicacies. Adults could enjoy all these treats plus beer and have a chance to sit on the wooden-plank benches, visit with friends, and enjoy patriotic music from the bandstand. The day concluded with a fireworks display in the farm field just across the street. The Frankenmuth Band, depicted here, might alternate with other bands or choirs over the course of the afternoon. By the time the fireworks were over, both adults and children were ready to call it a day.

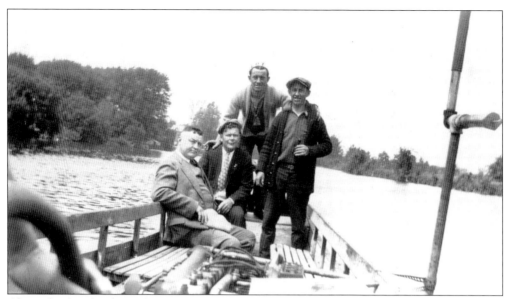

Above the dam for almost four miles upstream, the impounded waters of the Cass River averaged 8 to 10 feet in depth. The group depicted here is enjoying a cruise on the locally constructed *Vaterland*. What appears to be a wine bottle is more likely a bottle of home-brewed beer, a community necessity during Prohibition.

World War I was the first real challenge to the community's patriotism. There had been general pride in the emergence of a united Germany under the leadership of the Prussian Lutheran kaiser. However, when war was declared, Frankenmuth gave its wholehearted support to the American war effort. Frankenmuth soldiers Edwin Schreiner (seated), Otto Trinklein (left), and Ruben Kern are pictured here in uniform.

As with much of America, World War I represented a loss of innocence. For Frankenmuth residents, the trauma was even greater, as the war was being waged against their former homeland. To justify what was initially an unpopular war, propaganda was employed to vilify the enemy, particularly the German kaiser. The resulting anti-German sentiment, justified or not, was a painful experience for the community that cherished its heritage. Not only did they have to choose sides, but they were also suspected of harboring unpatriotic sympathies. The response was unequivocal. Every bond drive, scrap drive, or other war effort exceeded expectations. Pictured here are the veterans who marched in the 1919 Memorial Day parade, indisputable proof of Frankenmuth's loyalty and devotion to the United States of America. In many ways, the era marked the ending of the isolationist ideal of both the community and the country. As with much so-called progress, there were losses as well as benefits.

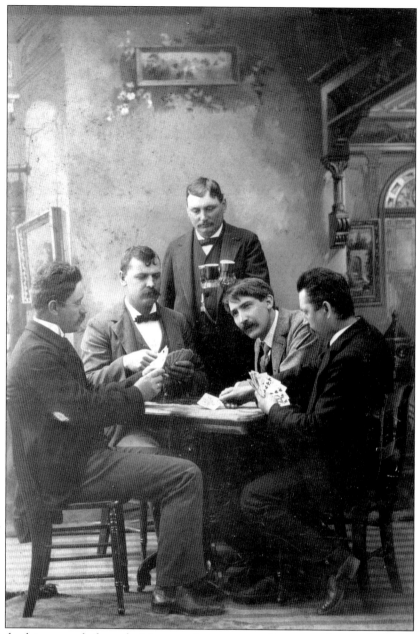

Looking back to an era before television, movies, or even radio, one might wonder how ancestors managed to tolerate those long, cold winter evenings. Actually, they managed quite well in devising their own entertainment. Card playing has always been a popular Frankenmuth pastime. Even today, poker and euchre tournaments are sponsored by local taverns and clubs. But the game depicted here is skat, a contest of German origin, being played here by three locals and a traveling salesman. From the evident concentration on the faces of the participants, it must have been a challenging task. They are so intent that they seem to be ignoring the refreshments offered by Lorenz Kern, the proprietor of the Commercial House. Possibly they have been oversated by the all-you-can-eat chicken dinner prepared by Kern's wife, who is credited with originating that delectable concept.

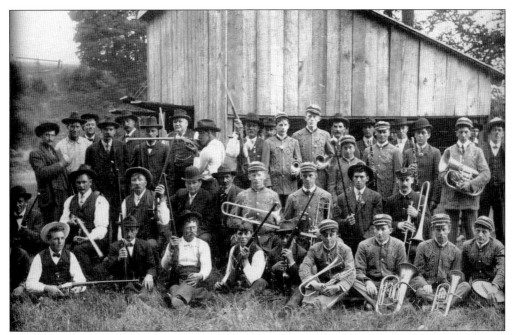

This photograph from about 1900 depicts the *Schutzenverein*, or rifle club, at Hubinger's Grove. Clubs like this were a natural outgrowth of the prolific hunting opportunities available in the area. Note the uniformed brass band and the solidly constructed building from which liquid refreshments were dispensed through windows and whose raised shutters are visible (at left).

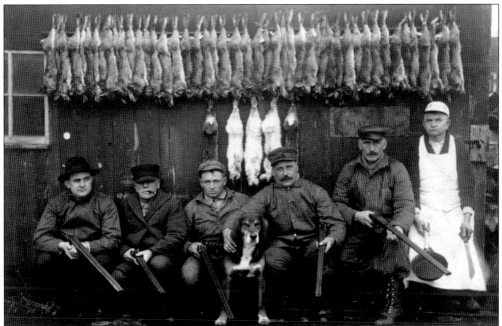

From the earliest times, the plentiful game found in the local woodlots supplemented the domestic meat supply. Game animals were often hung for a period to bring out the flavor. These hunters pose in front of their day's work. In the top row are the common and prolific cottontail rabbits, while beneath are the variable, or snowshoe, hares.

Beyond being a threat to the domesticated poultry population, foxes were thought to pose unacceptable risks to pheasants, rabbits, and squirrels. Since the latter provided edible small-game hunting, diminishing the natural risks to them was considered beneficial. Moreover, the fox pelts could be sold to provide funding for the local product in the foreground.

Before the introduction of the ringed-neck pheasant, the ruffed grouse, or partridge, was a prime small-game quarry. In the early years, the distinction between hunting for meat and hunting for sport was not always scrupulously observed. As with many natural resources, the plentiful populations seemed inexhaustible, often resulting in excessive harvesting.

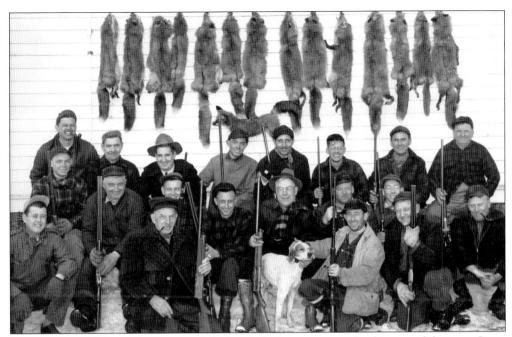

What originated as predator control for local chicken coops evolved into a club sport. Since almost every local farm had a substantial woodlot, there were plenty of favorable habitats for the wily foxes. The post-hunt tally was often followed by appropriate liquid refreshment and socializing over the card tables.

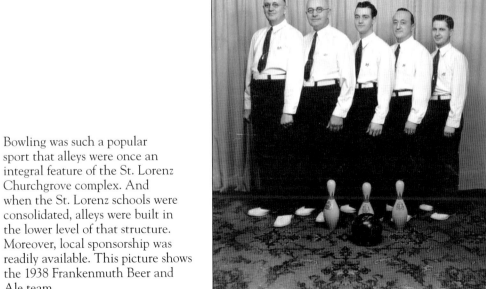

Bowling was such a popular sport that alleys were once an integral feature of the St. Lorenz Churchgrove complex. And when the St. Lorenz schools were consolidated, alleys were built in the lower level of that structure. Moreover, local sponsorship was readily available. This picture shows the 1938 Frankenmuth Beer and Ale team.

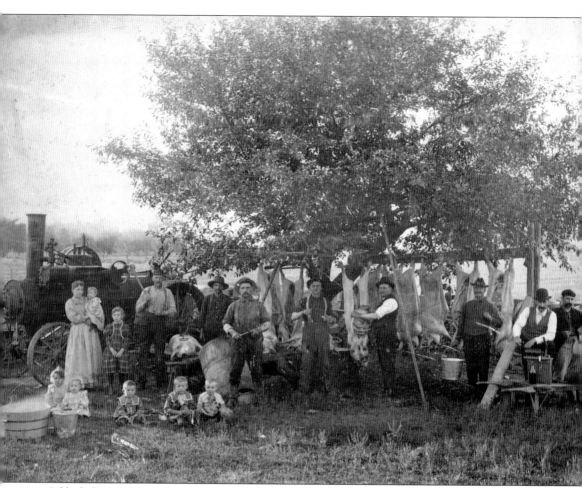

Schlachtfest was, literally, a butchering party. Like barn raisings or threshing bees, it was yet another example of a necessity being converted into a festivity. Family and neighbors all participated in the task of transforming hogs into sausage, bacon, hams, and so on. Much of the meat was preserved by smoking. Other cuts were fried down and then covered with lard as a preservative. The lard was an essential byproduct of the butchering. This photograph of a Kern family *Schlachtfest* clearly shows participants of all ages, including children, who certainly were aware that meat did not originate in grocery stores. The buckets held boiling water to scald the bristles from the carcasses. At the conclusion of a hard day's labor, the participants enjoyed a sampling of the end products. Another portion was given to the local pastors and teachers. Many of the sausage recipes, brought from the old country, are still used in local butcher shops today.

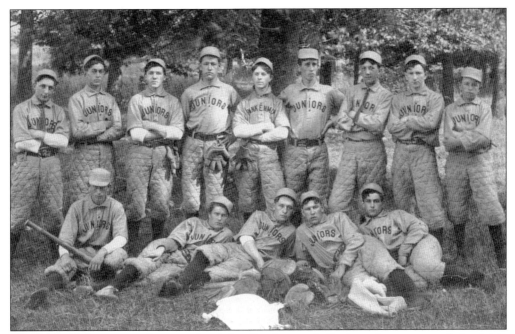

This early-20th-century photograph of the Frankenmuth Juniors shows some of the fairly primitive baseball equipment of the era. Yet they are nattily attired in matching uniforms. Many local merchants sponsored teams out of genuine appreciation for the sport or from community pride, without the advertising of later times.

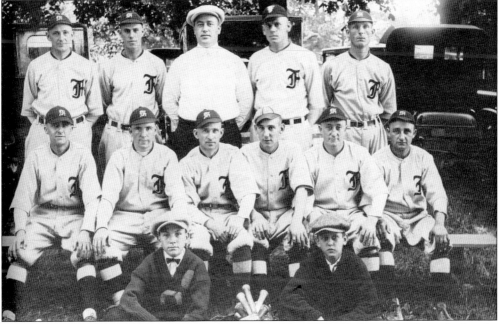

This baseball team is clearly beyond school age. Many leagues were formed purely for the enjoyment of the sport and the opportunity to notch victories over nearby community teams. Numerous fields were available, and an appreciative audience of fans generally attended the contests to cheer on their favorite team.

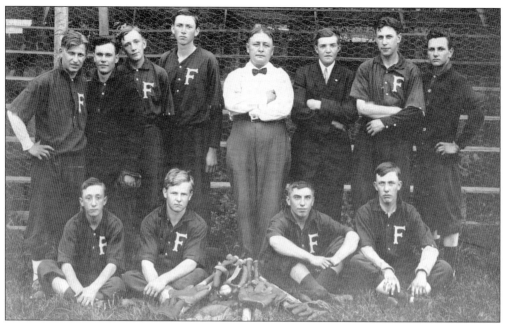

Physical outdoor labor in the farm fields produced muscles that made the various Frankenmuth athletic teams into formidable opponents. The community also took an active interest in intercommunity competition, whether school sponsored or club organized. Beyond the chicken-wire fence, sturdy bleachers are evidence that the games were heavily attended by the locals.

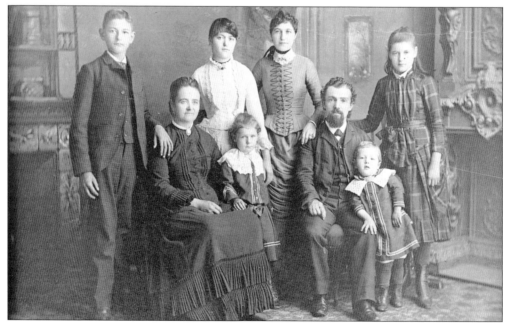

This 1880 picture of the Etter family was taken in the parlor, a room that was reserved for entertaining and special occasions. Families of six or more children were common in that era, with the older children helping to care for the younger ones and all sharing in the eventual responsibility of caring for aging parents and grandparents.

This Nuechterlein family photograph from the 1880s is indicative of the relative prosperity being enjoyed only a generation after Frankenmuth was founded. The family originated in the Franconian village of Rosstal, as did most of Frankenmuth's first settlers. In addition to their shared religion and cultural heritage, there were also family ties dating back to their village of origin.

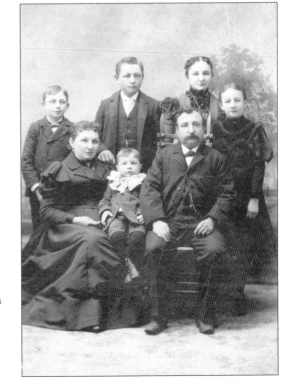

The Theodore Fischer family was among the earliest local hotel proprietors. Such enterprises typically involved delegating tasks to each family member. As a result, the businesses often passed down through several generations, with management abilities having been gained through practical first-hand experience. Such hands-on expertise still characterizes many of today's businesses.

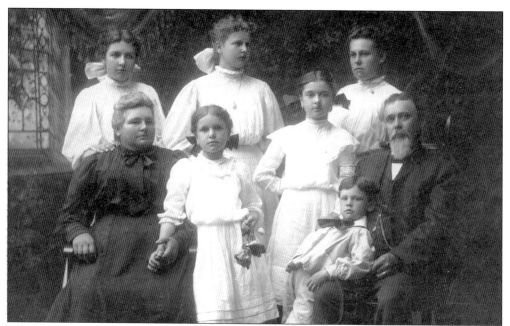

The Mike Bernthal family was descended from one of Frankenmuth's original settlers. It was testimony to their hard work and the fertility of their fields that they had achieved a substantial measure of prosperity by the time of this 1905 portrait. That work ethic remains a defining characteristic of the community.

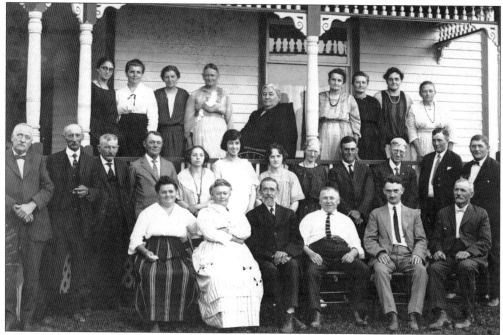

This picture of a Gugel-Bierlein family get-together is typical of the era. Relatively large families often remained in close proximity so that birthday and anniversary celebrations were frequent and well attended. During warm weather, the festivities were often held outdoors either in the side yards or picnic groves. (Courtesy of Wallace Weiss.)

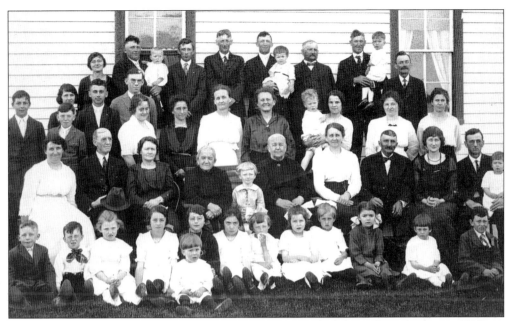

This 75th birthday celebration of Christina Weiss is typical of the early 20th century. William Stromer, the professional local photographer of that era, produced a print copy for each family depicted. Consequently, it is fortunate that so many are available for preservation. While sometimes a challenge, most of the individuals have been identified, making the pictures even more meaningful.

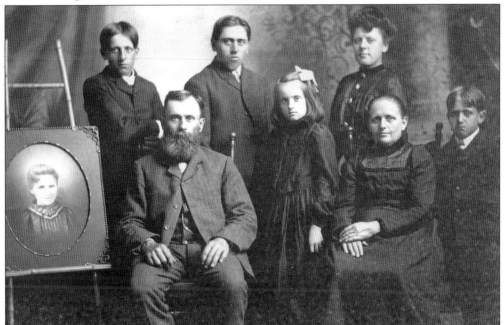

One of the less pleasant aspects of the good old days was the prevalence of often fatal childhood illnesses. In this George Bernthal family photograph, deceased daughter Sophie is included by means of the portrait to the left. Childhood epidemics often simultaneously claimed several members of the close-knit community.

Funerals have always been bittersweet occasions in the local Lutheran tradition. Sorrow at the loss of a loved one is tempered by assurance of a better life for the departed. Then, as now, floral tributes to the deceased from relatives and friends were displayed at the ceremony, which would be followed by the fellowship of a shared meal.

Funerals were solemn, yet celebratory events. In this photograph, a portrait of the deceased is displayed on the casket. The floral-surrounded clock probably indicates the time of death. The various tributes often identified the relationship of the departed to the donor, as with the wreath labeled "uncle" (upper right).

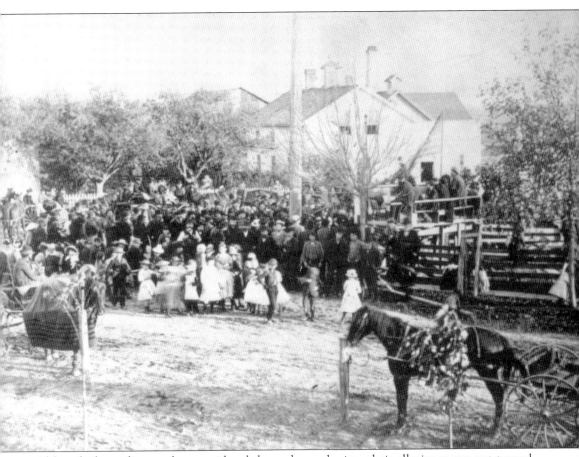

Although the earliest settlers considered themselves colonists, their allegiance was not toward the disliked Bavarian government but rather toward some broader Germanic principle. In fact, their American citizenship required them to specifically renounce all allegiance to the Bavarian king. Other than dutifully paying their taxes, they had few interactions with government. They provided for their own, when need arose, and avoided the courts in favor of amicably resolving any disputes that might arise. They considered this their Christian duty. When they did eventually adopt political partisanship, it was on the basis of which party seemed most in step with agrarian interests. Because the community was so closely knit, election results were usually nearly unanimous. But they never ignored a good excuse for a celebration. This 1886 photograph depicts a "pole-raising" in honor of the election of Grover Cleveland as president. Local brewer John Geyer furnished the venue and likely the celebratory refreshments.

ACROSS AMERICA, PEOPLE ARE DISCOVERING SOMETHING WONDERFUL. *THEIR HERITAGE.*

Arcadia Publishing is the leading local history publisher in the United States. With more than 3,000 titles in print and hundreds of new titles released every year, Arcadia has extensive specialized experience chronicling the history of communities and celebrating America's hidden stories, bringing to life the people, places, and events from the past. To discover the history of other communities across the nation, please visit:

www.arcadiapublishing.com

Customized search tools allow you to find regional history books about the town where you grew up, the cities where your friends and family live, the town where your parents met, or even that retirement spot you've been dreaming about.